SWORDS & SORCERY!

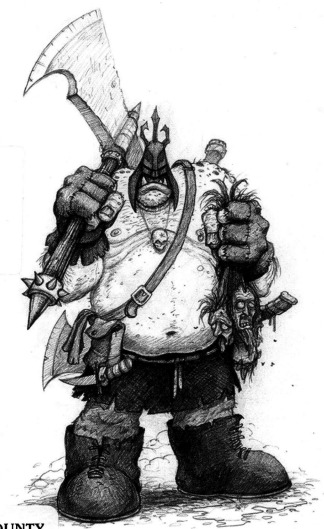

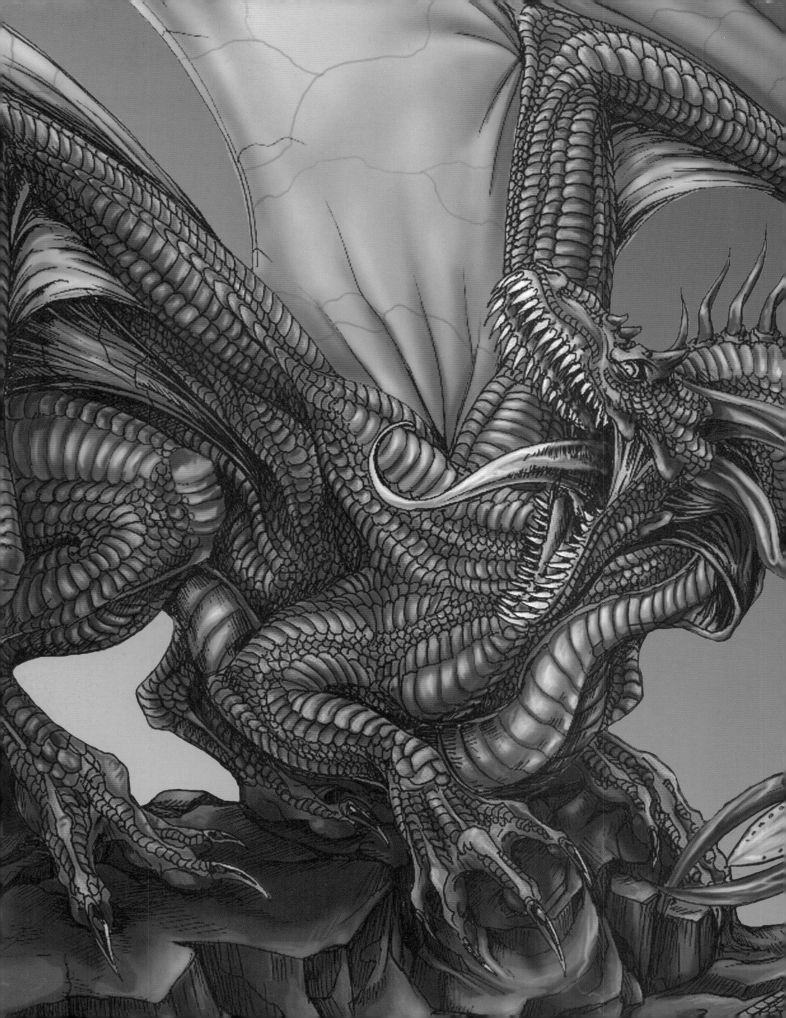

SWORDS & SORCERY!

HOW TO DRAW FANTASTIC FANTASY ADVENTURE COMICS

BRYAN BAUGH

WATSON-GUPTILL PUBLICATIONS
NEW YORK

Senior Editor: Candace Raney
Editor: James Waller
Designer: Jay Anning

Frontispiece: *Executioner,* by Adam Vehige.
Title page art: *Red Dragon,* by Allison Theus.

First published on 2007 by Watson-Guptill Publications,
Nielsen Business Media,
a division of The Nielsen Company
770 Broadway, New York, NY 10003
www.watsonguptill.com

Library of Congress Control Number: 2007922225

Printed in China

First printing, 2007

1 2 3 4 5 6 7 8 9/10 09 08 07

This book is for every kid who ever submitted an
awesome drawing of a dragon to the high school art contest . . .
and lost first prize to the kid who submitted
a mediocre drawing of a bowl of fruit.

Contents

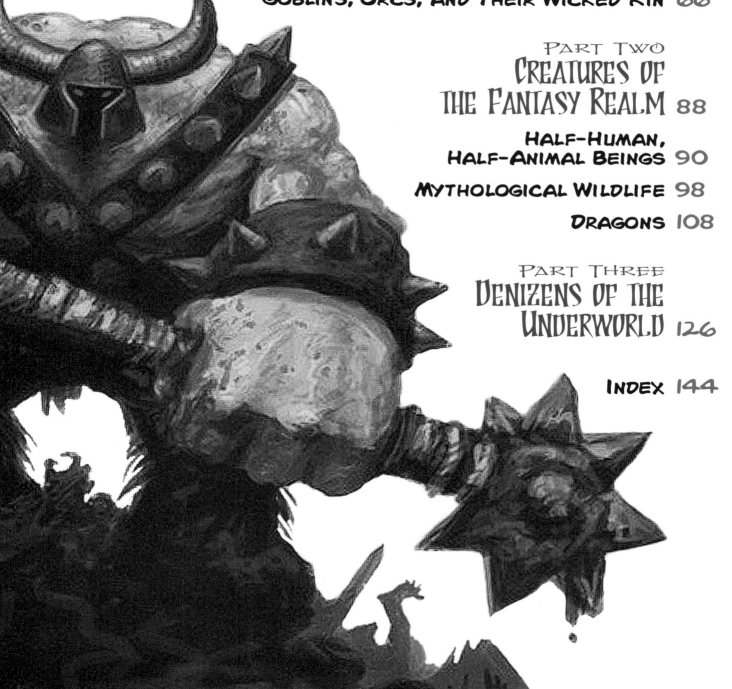

About the Artists 8

Introduction 9

PART ONE
Humans and Subhumans 14
Adventurous Heroes 16
Seductive Heroines 40
Dastardly Villains 56
Goblins, Orcs, and Their Wicked Kin 66

PART TWO
Creatures of
the Fantasy Realm 88
Half-Human,
Half-Animal Beings 90
Mythological Wildlife 98
Dragons 108

PART THREE
Denizens of the
Underworld 126

Index 144

About the Artists

Bryan Baugh regularly works as a storyboard artist in the animation industry. He has worked for Disney Animation, Warner Bros., Sony Television Animation, and other companies. His credits include shows such as *The Batman, Jackie Chan Adventures, Roughnecks: The Starship Troopers Chronicles, Teenage Mutant Ninja Turtles, Harold and the Purple Crayon, Men in Black, Masters of the Universe,* and *My Friends Tigger and Pooh.* He illustrated the graphic novel *The Expendable One* for Viper Comics, and he also writes and illustrates his own comic book creation, *Wulf and Batsy.* He lives in Thousand Oaks, California, with his lovely wife, Monica, and three bloodthirsty killer cats—Lucy, Tiger, and Kayla. You can view more of his work at his Web site, www.cryptlogic.net.

Kerem Beyit was born in Ankara, Turkey. He started drawing in early childhood, taking inspiration mostly from comic books. He studied graphic design for four years at Ankara's Gazi University. Although he had no formal training in illustration, he trained himself by studying great fantasy artists like Frank Frazetta and Brom. He has done graphic and illustration studies, book covers, local comics, magazines, and books for children. For two years he has been creating digital book covers, and he has been named an elite member by both CG Channel and GFX Artist. Recently, his art has appeared in such publications as Ballistic Publishing's collections *Exposé 3, Exposé 4,* and *Exotique.* He formerly worked for Céidot Studios in Turkey as a concept artist and illustrator but now freelances.

Bill Bronson is a kid at heart. He still watches cartoons from time to time and is a huge fan of chocolate chip cookies. He has a fascination with drawing robots and monsters, watching horror and sci-fi movies, and listening to heavy metal and punk rock. You can view more of his work at his Web site, www.billbronson.com.

Jeff Fairbourn has been cursed with an unrelenting imagination for his entire life. It has been a source of pain and providence, a curse and a quest. Fantasy and illustration are a daily staple for him. He's been inspired by many different artists of the fantasy genre, from legends like Frank Frazetta to an ever-growing number of amateur artists. Jeff's written works and visual art have been published in *Dungeon* magazine (Paizo Publishing) and have appeared on local high school walls and floors and been broadcast on television commercials. His online gallery can be viewed at http://faile35.deviantart.com. Jeff currently lives in the western United States with his wife and three children.

Benjamin Hall has been a professional illustrator since 2000. He has worked as a concept artist on the computer game *American McGee's Alice* and illustrated the covers and interiors of several comic books, including a year's run on *Knights of the Dinner Table: Everknights* as well as the *Dead@17: Protectorate* miniseries and several short stories and anthologies. He lives in the Dallas–Fort Worth area with his wife, Marlena. Their Web site is www.blueskycomics.com.

Marlena Hall is a color artist and Web designer. Originally from Las Vegas, she currently resides in Arlington, Texas. Since 2001, she has colored such comic books and graphic novels as *Dead@17: Protectorate* and *Karma Incorporated* and short comic stories in the anthology titles *Villains, Dead@17:Rough Cut* (volumes 1–3), *Western Tales of Terror* (issues 2, 4, and 5), and *Knights of the Dinner Table: Everknights.* See her Web site at www.blueskycomics.com, and contact her at marlena@blueskycomics.com.

Zach Hall is a concept designer for video games; his most noteworthy credits are *Heavy Metal F.A.A.K 2, Duke Nukem Forever,* and *American McGee's Alice.* He has also begun to work in film, most recently as a second animator and conceptual designer on the feature film *A Scanner Darkly.* You can see more of his artwork at his Web site, www.zachhall.com.

Mauro (Mauricio) Herrera is a Chilean artist who has been illustrating for more than twelve years. His primary media are digital paint, Photoshop, Painter, and Intuos Tablet. At this writing, he is involved with a group called Berserker Comics and is working on a series called *Diablo Cronicas.* You can see more of his artwork at http://el-grimlock.deviantart.com and www.diablocomic.com.

Grzegorz Krysinski describes himself as a digital painter. He has created many masterful digital paintings, mostly revolving around science fiction or fantasy themes, and has provided illustrations for publishing houses in his home country of Poland. You can see more of his artwork online at http://czarnystefan.digart.pl/digarty and http://czarnystefan.deviantart.com.

Daniel Lundquist lives in Sweden. At the time of this writing, he is only eighteen years old, but he is already proving to be an extremely talented fantasy and science fiction artist. He has most recently created artwork for Arenan.com, a Swedish online gaming community. He hopes to do more work in illustration and concept design. You can view more of his artwork at his personal Web site, www.dlart.se, and you can contact him at contact@dlart.se.

Amelia Mammoliti is a student at the Academy of Art, University of San Francisco, working toward her bachelor's degree in illustration. Her work has appeared in publications such as *ImagineFX* and Ballistic Publishing's *Exotique 2.* You can view more of her artwork online at http://nanya.deviantart.com, and she can be contacted at amelia_stoner@yahoo.com. She lives with her husband in Sacramento, California.

Allison Theus is a freelance concept artist and illustrator working primarily in sci-fi and fantasy. She has been creating unique creatures and worlds for over ten years. Among other projects, Allison has worked on Mage Warfare, a card game produced by Gogra Games. She is currently working on concept art for the IGF Project at Carnegie Mellon University's Entertainment Technology Center, where a group of seven students are creating a game to submit to the Independent Games Festival in 2008. She is also doing concepts and illustrations for Mythbinder, an upcoming MMO game.

Adam Vehige graduated from the Kansas City Art Institute in 2000 and has been working as a professional illustrator ever since. In 2005 he went freelance, creating Vehige Studios. His passion lies in fantasy art and concept design. Adam's greatest inspirations are nature and the art of his contemporaries. You can view more of his artwork at http://vegasmike.deviantart.com/gallery. He currently lives in Missouri.

Dave White is a classically trained artist with an interest in all forms of illustration and animation. When not drawing giant robots or making video-game models of amazon elves, he likes to hang out at comic conventions chatting with other artists. Dave's freelance career continues to entertain him as he creates art for how-to-draw books, toy designs, trading cards, video games, comic books, and pretty much anything else that is fun and comes with a paycheck! Be sure to check out Dave's Web page, www.mechazone.com.

Introduction

SOME CALL IT "FANTASY ADVENTURE." Some call it "medieval," or "mythological adventure." Some call it "sword and sorcery." Call it what you like, the fantasy genre is a realm of battle-hardened, bloodthirsty barbarians, of bold knights in armor, of kings and castles, of innocent princesses and sultry sorceresses, of five-headed hydras and fire-breathing dragons, of magicians and magical creatures, and of terrifying monsters of every description.

Fantasy stories are set in worlds both ancient and untamed. The land is mostly wild and unsettled. What civilizations do exist are thinly scattered and tend to be peopled by a mix of dangerous ruffians and cowering peasants. And between these small havens lie endless reaches of wilderness requiring days or weeks to traverse. The crumbling ruins of centuries-old cities lean in the shadows of magnificent towers and castles. Fog-shrouded swamps, haunted forests, and crashing, cobalt oceans darken every horizon. Snow-laced mountains loom into the misty sky and obsidian caves lead down into subterranean underworlds of fire and death.

These environments are inhabited by varieties of wildlife that include not only our own familiar, earthly animal kingdom but also monsters from legend, fairy tale, and myth. These include creatures both good and evil—from benevolent, magical unicorns, to slobbering, man-eating trolls. There are intelligent, nonhuman races, such as elves and dwarves, as well as sub-intelligent, humanoid monsters, such as giants and orcs. And of course there are dragons. As you will see in this book, even dragons come in a wide range of shapes, from sleek, flying serpents to hulking, lumbering lizards.

Fantasy stories range from the simplest treasure hunt to the rescue of a captured princess from some vile enemy to epic tales of medieval warfare. Perhaps the most famous and influential works shaping this genre have been the writings of J. R. R. Tolkien, especially his *Lord of the Rings* trilogy, and the Conan the Barbarian works of Robert E. Howard. *The Lord of the Rings* and the Conan novels couldn't be more different from one another, yet both are classic, defining works of fantasy adventure fiction. Marking opposite poles of the genre, Tolkien's and Howard's work establish—and simultaneously work against—many of fantasy fiction's standard formulas.

The Lord of the Rings is a classic treasure-hunt story in reverse: here, the characters take possession of the treasure at the very beginning of the story. Unfortunately, that treasure happens to be a ring filled with evil magic, which corrupts anyone who keeps it for too long. The sinister ring's power is so great that it can only be destroyed by throwing it into the volcanic lava of Mount

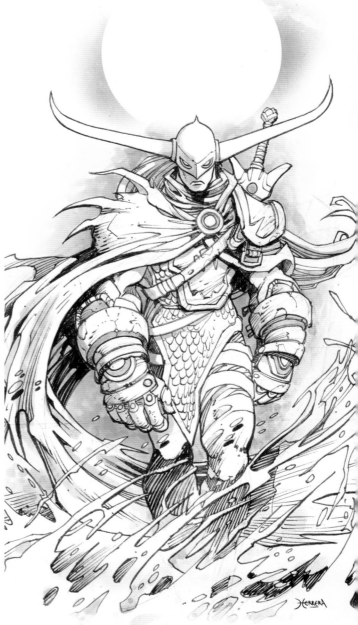

Lugh
An intimidating warrior splashes through the shallow waters of a flooded region. (Art by Mauro Herrera.)

Doom, in the hellish, faraway land of Mordor. Thus our heroes set out on their long and perilous journey not to search for a lost treasure but rather to rid themselves of a found treasure.

Conan the Barbarian and its many sequels chronicle the life of the muscle-bound, wandering warrior Conan as he travels from one civilization to the next, getting into outrageous, often blustery, and always bloody adventures everywhere he goes. The Conan stories prominently feature giants, monsters, and ferocious animals that must be bested, and, of course, drop-dead-gorgeous women who must be won. Not that any of this presents much challenge to good old Conan. When his enemies attack, they come in droves—a crowd of mad-eyed killers hurtling themselves at our hero, only to be cut down left and right by his blade and his fists. The classic Conan image is that of the grim-faced barbarian, in all his blood-smeared, battle-scarred glory, standing atop a mountain of the twisted, entangled bodies of those who have opposed him. (Such images

◄ **Searching among the Graves**
Two bold knights cautiously make their way through an eerie graveyard (Art by Dave White.)

▶ **Green Dragon**
This confrontation with a dragon is a classic fantasy image. (Art by Bill Bronson.)

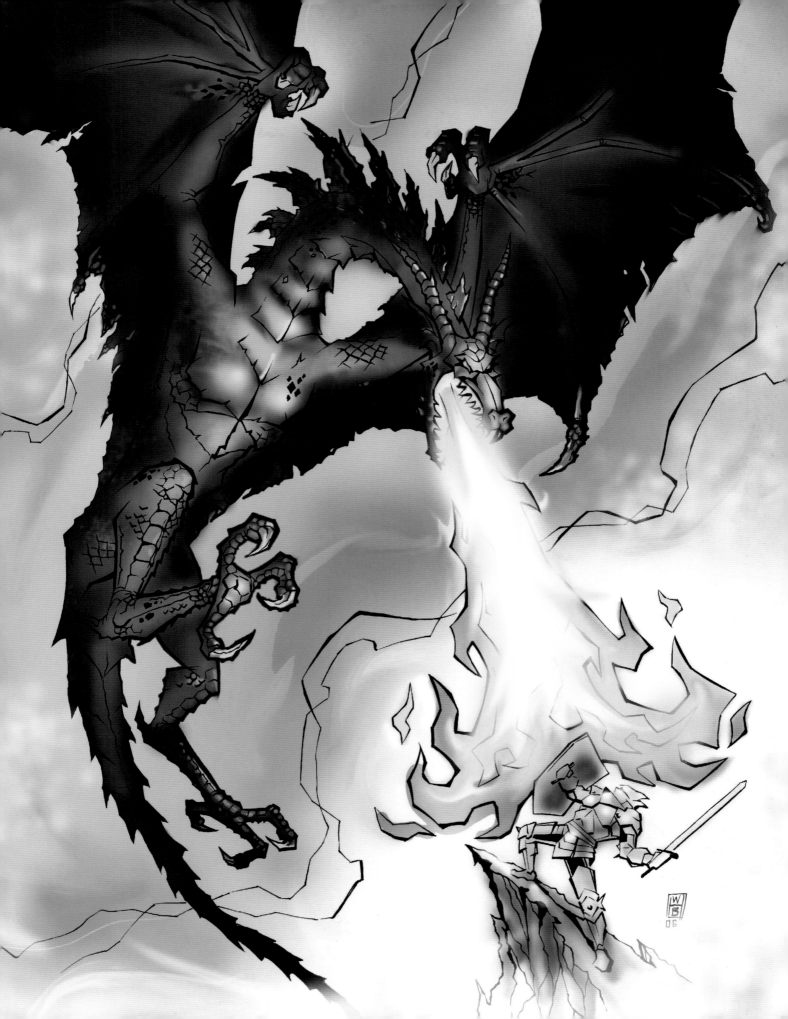

were best depicted by Frank Frazetta in his painted cover illustrations for the 1960s editions of the Conan books.) The constant narrative through-line in this series of books is Conan's personal goal to someday become a king by his own hand. While they may not be the most suspenseful or unpredictable stories ever written, they nevertheless nailed down many of the classic tenets of fantasy fiction. And, with Conan's endless succession of victories in the face of impossible odds, the stories have a potent effect on the imaginations of male readers. If *The Lord of the Rings* is the ultimate epic fairy tale for children, then the Conan novels are the ultimate, testosterone-laden power fantasies for men.

The fantasy genre has served as the basis for a number of different comic book series. The most famous and successful of these—as you might expect—have been the various comic adaptations of the *Conan the Barbarian* stories. Not quite as popular have been the flood of comics that imitate the Conan formula, featuring obviously similar barbarian

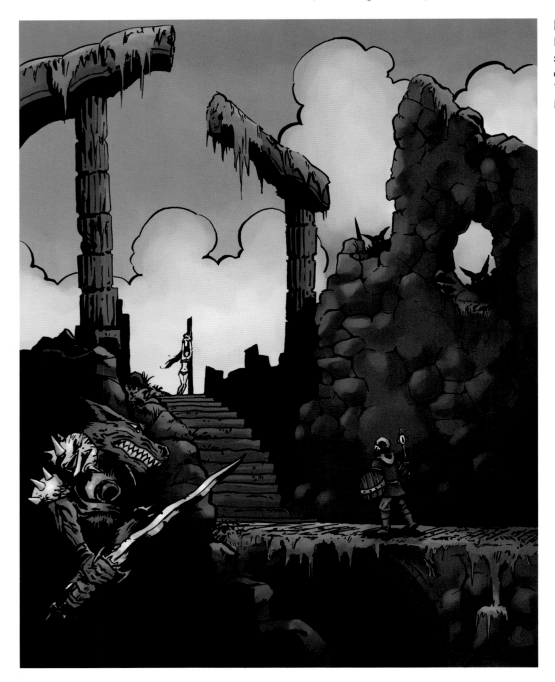

Deadly Ruins
Danger lurks in every shadowy corner of these ancient ruins. (Art by Dave White, colors by Benjamin Hall.)

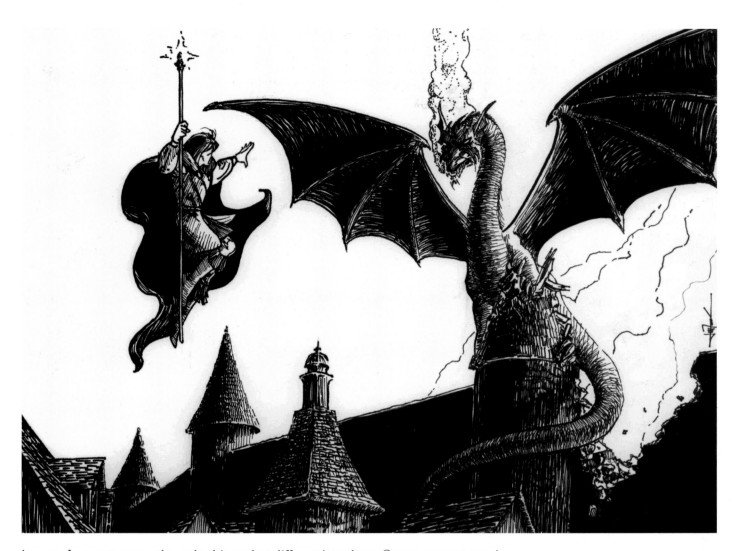

heroes. In many cases, the only things that differentiate these Conan-copycat comics from their inspiration are the lead character's name and hair color.

More imaginative fantasy comic series have included such titles as *Red Sonja* (also based on a Robert E. Howard character), about the adventures of a sword-wielding female warrior, and *Elfquest,* by Richard and Wendy Pini, about the lives and adventures of a group of elves.

Another truly imaginative fantasy series was *Elric of Melnibone,* illustrated, most notably, by P. Craig Russell and based on a series of novels by Michael Moorcock. Here was a genuinely unique fantasy series that couldn't have been more different from *The Lord of the Rings* or the Conan stories. The *Elric* books told of the adventures of a skinny, wraithlike warrior—an albino with ghostly white skin, a mane of long, white hair, and beaming red eyes—whose powerful sword was actually a demon. Called Stormbringer, the sword served Elric but also threatened to turn itself against him if he did not use it regularly—to sate the demonic sword's unquenchable thirst for human blood. Thus Elric emerged as a morally and emotionally torn antihero, equal parts noble adventurer and cursed murderer, whose adventures brought him more anguish and tragedy than glory.

In this book, you will find useful lessons for learning to draw the many characters that populate the world of fantasy, so that you can apply those lessons and illustrate your own fantasy comics.

One Wizard Will Stand

An outlaw wizard takes to the skies for a fierce battle with a draconic enemy. (Art by Jeff Fairbourn.)

PART ONE
HUMANS AND SUBHUMANS

I F YOU ARE INTERESTED IN LEARNING TO ILLUSTRATE COMIC BOOKS, you've probably already spent a lot of time drawing your own heroic characters. You've probably looked at a lot of comic books to see how professional artists handle their characters, and I'm betting you already own a pile of other books on how to draw dynamic comic book–style characters. Well, that's a good thing, because you will need that fundamental background knowledge to tackle the more advanced challenges that lie in the pages ahead.

The purpose of this book is not to teach you basic figure drawing, but rather to show you how to take the basic things you already know about drawing dynamic characters and add a fantasy or "sword and sorcery" slant to them.

This is the ideal place to begin—with the human and humanoid characters who belong to this genre. All the characters in this part of the book have a basically human anatomy—in other words, each has one human or human-like head and body, two arms, and two legs. If you can learn to draw these characters, it will be a simple matter to take these same basic lessons and apply them to characters in the later parts of the book, many of whom display totally nonhuman forms. So strap on your battered armor and your leather boots, grab your magic spell book and your rusty, blood-stained sword, and let's get started!

Sword and Sorcery
A barbarian and a female wizard are surrounded by a horde of terrible monsters in this frightening yet comical scenario. (Art by Bryan Baugh.)

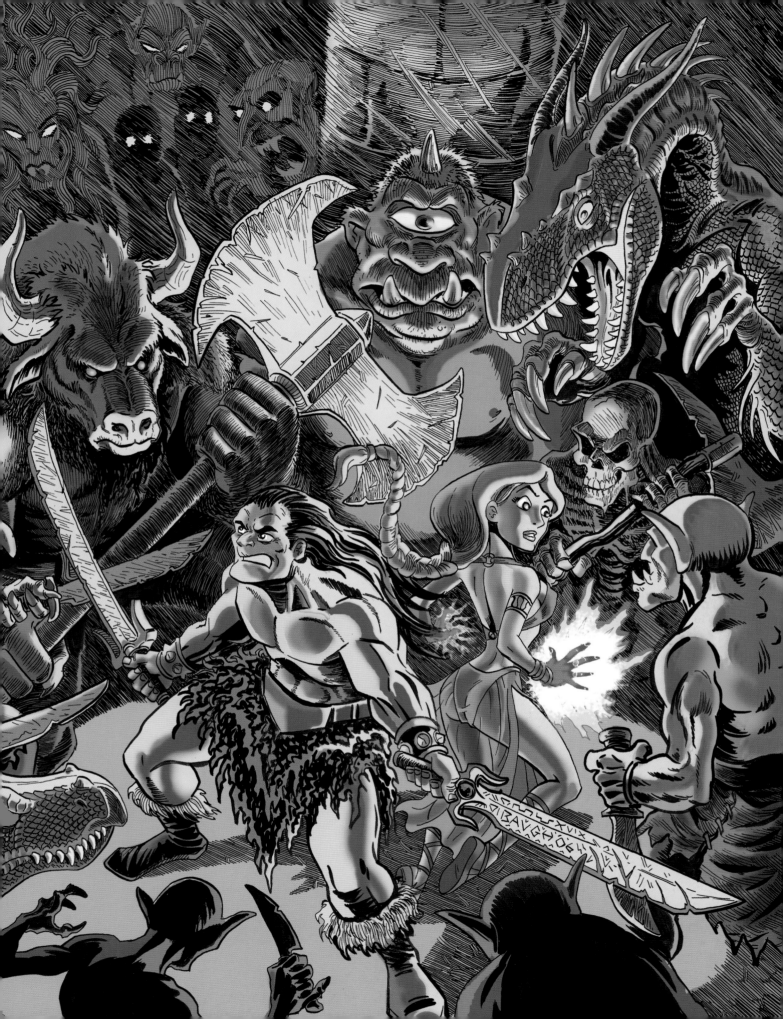

Adventurous Heroes

RYING TO SURVIVE IN A MEDIEVAL, mythological world—one in which monsters, dragons, and other evil beings run rampant—is a tough life, to say the least. It's not easy to create an existence of peace and quiet, and it's even more difficult to make a steady living. Many men seek out military careers, as knights fighting in the service of the nearest kingdom. It is these men's hope to survive as many battles as they can, to rise in the ranks, and possibly even to become kings themselves.

But such opportunities are not available to all. Even becoming a lower-level infantryman in the king's army may not be possible for those men lacking the physical strength, the heritage, or the disciplined, selfless mindset needed to excel in such a position. Such men must carve out a living on their own. They may become mercenaries or freelance adventurers, traveling about from place to place, seeking employment from those in need of the violent services such warriors offer. In many ways, this kind of man leads the most interesting life of all. One week he might take on a dangerous mission to rescue a captured princess; the next week he may find himself working as a bodyguard for a wealthy client. In between jobs, he may be forced to rob a jewel-encrusted temple or hunt for lost treasure—essentially, to make a living by stealing and then selling valuable items to have enough money to pay for food and lodging. Noblemen are usually not proud of such behavior, but—from their point of view, living in a harsh and unforgiving medieval world—an occasional crime is nobler than starvation.

Barbarian versus Orc Mob
As this illustration demonstrates, a mob of bloodthirsty orcs is no match for one good barbarian. (Art by Bryan Baugh.)

When drawing heroic male characters, keep in mind that there are certain things you can do to make them look genuinely heroic. For example, exaggerating the size of the shoulders and hands, the thickness of the arms, and the breadth of the chest and shoulders while keeping the waist trim and narrow can result in an instantly heroic-looking upper body. Another good trick is to spread the legs apart a bit, even when the character is standing in a neutral position. A simple trick like this can give the character a sturdier, bolder stance. And when drawing him in a standing pose, give your heroic male character a very straight back. Keep his posture tall, bold, and confident. He is a hero, remember, so he's got to carry himself like one. If the character is in an action pose, then get his body bending forward, lunging toward the action. Always keep these helpful pointers in mind when drawing this type of dynamic figure.

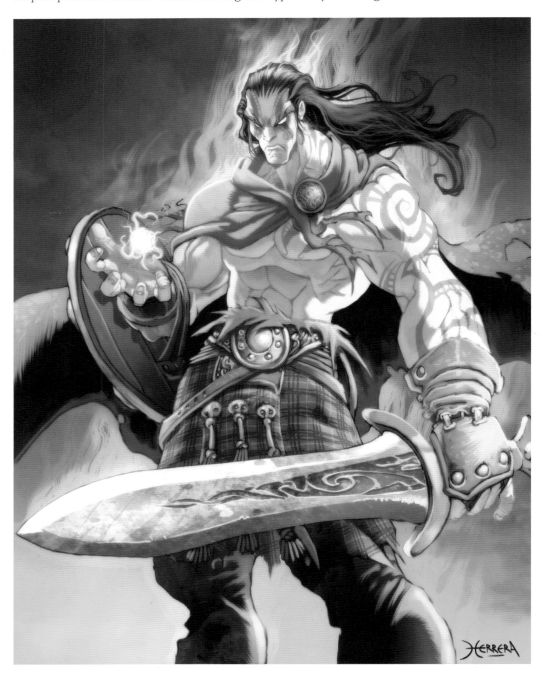

◄ **The Celtic Warrior**
Notice this character's bold stance and solid posture. The Celtic warrior appears dynamic and powerful even when just standing there doing nothing. (Art by Mauro Herrera.)

► **Alastor**
The proud warrior Alastor stands over the head of a creature he has slain. (Art by Mauro Herrera.)

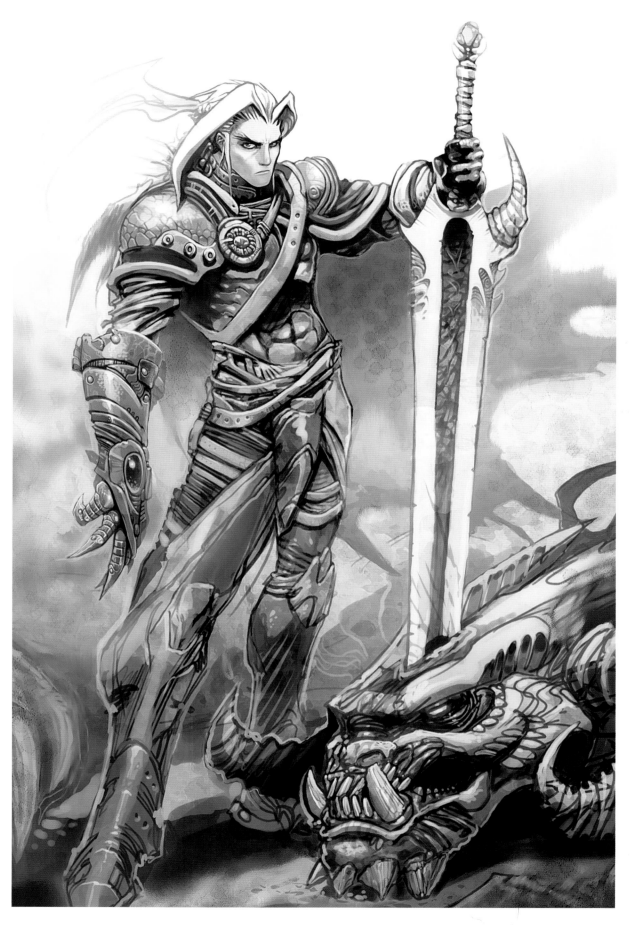

When drawing any kind of fantasy character, you want always to be thinking about who they are, what kind of life they lead, and what kind of situations they have encountered in the past. You can, and should, show evidence of your hero's past adventures in your drawings. A hero without a few scars probably hasn't seen much action. So give him scars—perhaps a few healed claw-marks on his body from fighting wild animals, or some scarred slashes on his arms from blocking knife and sword attacks. Furthermore, a hero with a perfectly clean-looking sword or battle axe probably hasn't used it much. Give that weapon a sense of history! Put some nicks and notches in the blade. Prove that it has a history of crashing into enemy swords—and whacking enemy skulls.

In short, you've got to believe in your characters as you draw them. Think of them not as drawings that you are struggling to "get right" but as real people whom you are putting down on paper. Imagine your characters' lives and personalities, and you will see that same life and personality come out in your artwork. If you believe in your characters when you draw them, the people viewing your art will believe in them, too.

The Distant Traveler
This warrior wears a costume that combines ornately detailed armor plating with naturalistic animal hides and feathers. (Art by Dave White.)

▶ Lord Kalkin on the Battlefield
A weary knight takes a break after a long day of fighting. (Art by Jeff Fairbourn.)

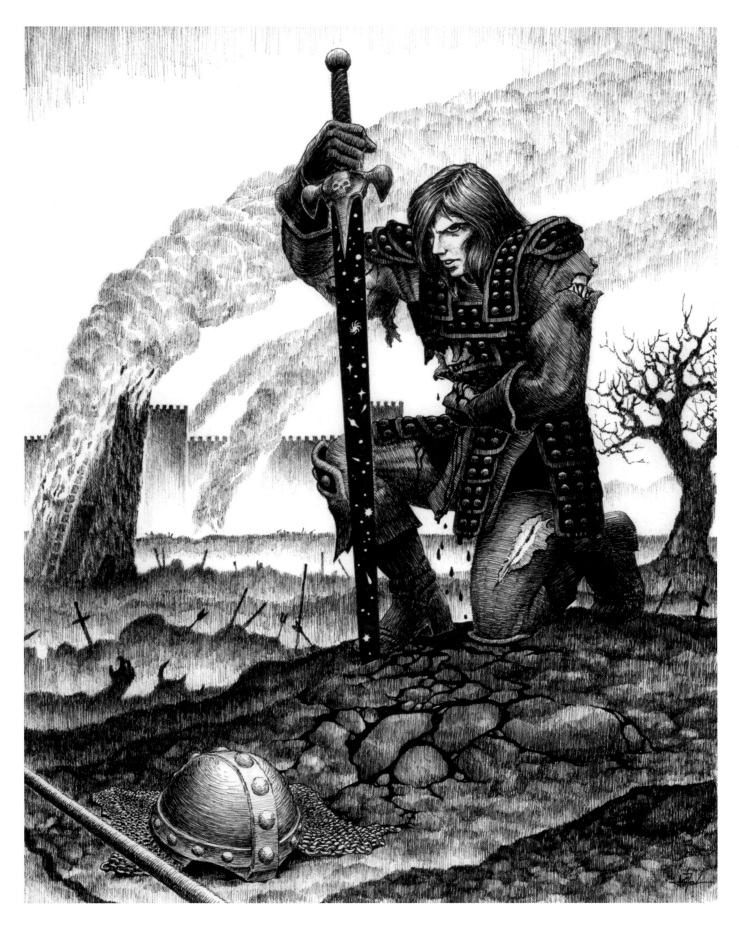

BARBARIAN

Perhaps no other human being lives a harder life than the barbarian. He is a man with no home, no formal occupation, and no family. Often, he is the last surviving member of a tribe that was wiped out by enemy forces. Thus his only means of survival is to master the skills of combat and swordplay and become a warrior for hire. He may lend his considerable talents to powerful kings, sultans, or criminal overlords— or even to ordinary citizens who have something to offer in return. Drawing this character gives you a chance to fall back on those old, tried-and-true superhero art techniques. This character is all about exaggeration for dynamic, heroic effect. When you lay out his basic form, exaggerate the width of his shoulders, the breadth of his chest, and the size of his muscles. Give him an impressive stance, with feet planted far apart. This makes him look heavier and more massive.

Portrait of a Barbarian
He might be a little dim-witted, but they don't come any tougher than this. (Art by Bryan Baugh, colors by Zach Hall.)

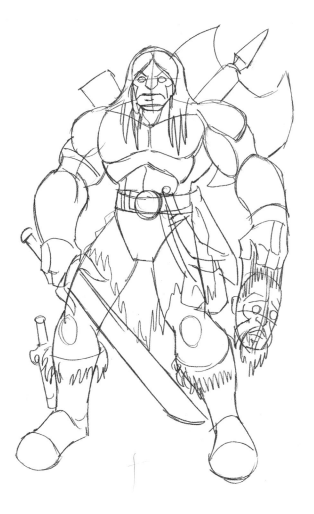

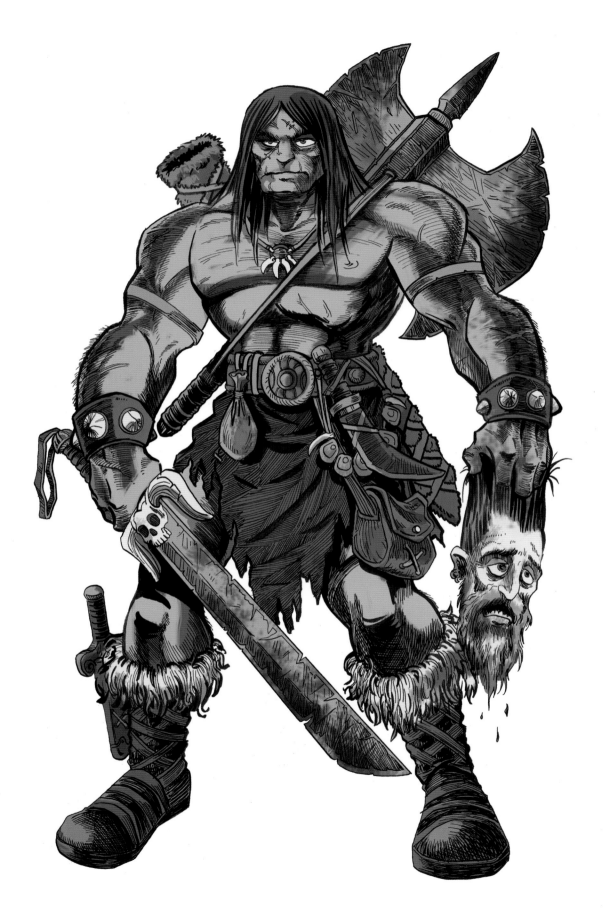

Barbarian Action Pose

This second depiction of our barbarian shows him in an action pose. Of course, this is only one of countless different poses you might create for this character, but it displays some of the ways you can change a character's sense of dynamism simply through adjusting his body, limbs, and facial expression. Notice that his whole body is thrust forward, creating a sense of urgency, and that he is rushing toward us. His arms and legs are bent, adding to his energy. Notice how his hair flies in the wind—this detail also gives the impression of movement. Finally, notice the extreme difference in facial expression between this character and the barbarian depicted on the previous pages, who is calm and at rest. Here, the barbarian is lunging into battle. His fiery eyes and snarling mouth clearly display his intentions. His enemy is in big trouble.

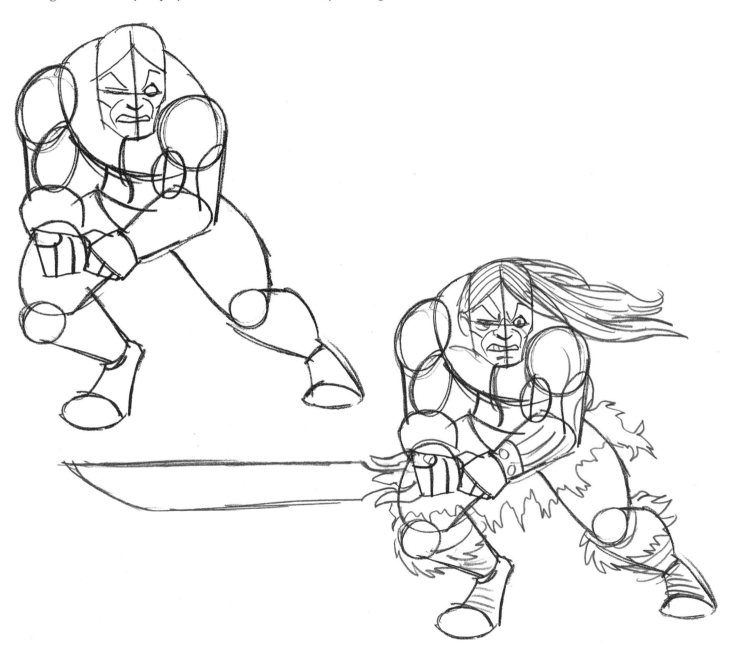

A Grim-faced Barbarian

This barbarian means serious business. You wouldn't want to make him mad at you. (Art by Bryan Baugh.)

RANGER

A man of the woods, the ranger travels long distances through untamed wilderness in his constant effort to make a living the only way he knows how—through his forest smarts and fighting skills. The ranger tends to be a somewhat nobler individual than the barbarian—often fighting in the service of oppressed people and those in need. Some rangers are actually descendants of high-placed families who, for whatever reason, have struck out on their own. Drawing the ranger is an exercise similar to drawing the barbarian; a heroic male, the ranger also needs broad shoulders and a strong stance, with his feet planted far apart. But the ranger's overall body shape should be smaller and slimmer than that of the barbarian. Nail down his figure first, then add his costume and gear. Be sure to make his costume look worn-out and dirty. This is a man who spends most of his time in the wilderness, after all. Make him look like it!

Portrait of a Ranger
Rangers are good men who prefer peace. But they are highly skilled, fearless warriors when in battle. (Art by Bryan Baugh, colors by Marlena Hall.)

The Archer
A ranger takes aim with his bow and arrow during a fierce battle. (Art by Mauro Herrera.)

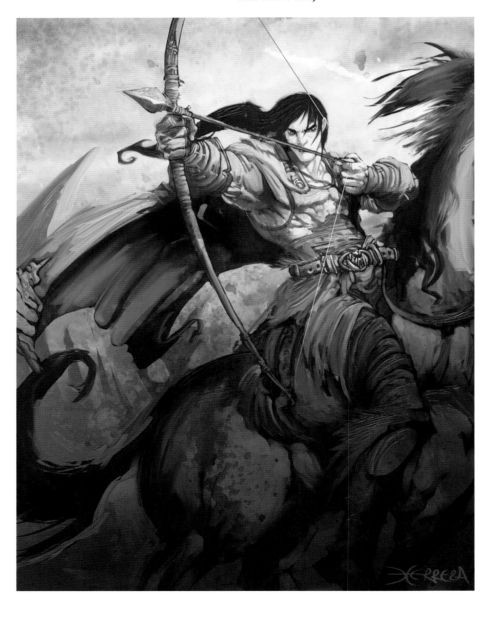

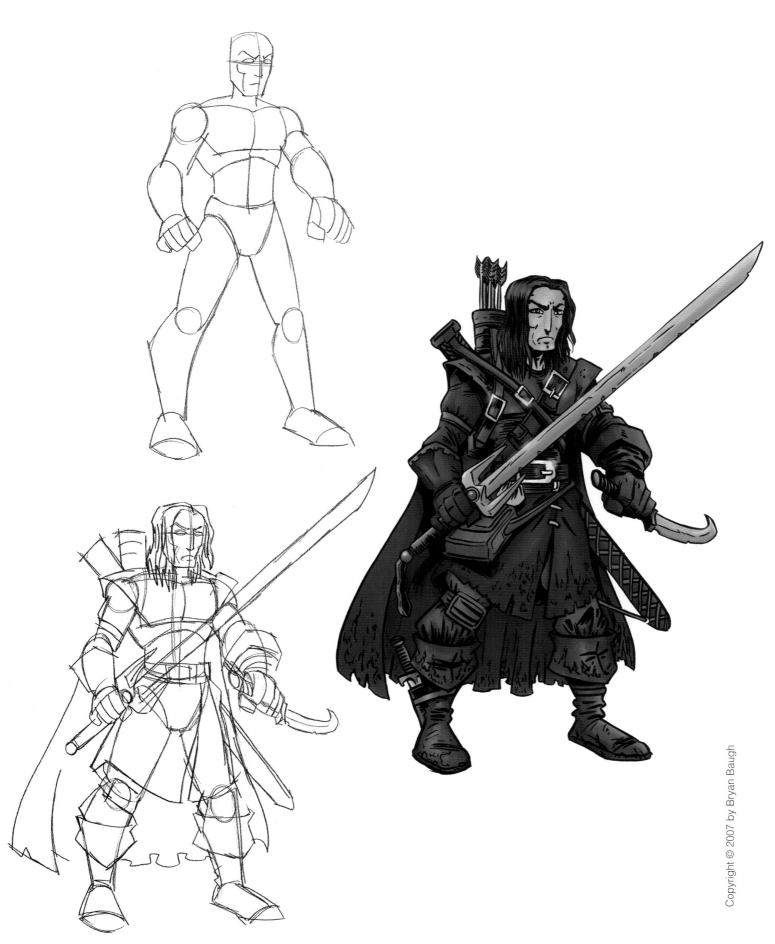

SWASHBUCKLER

An adventurer for the sake of adventure itself, the swashbuckler is less interested in the mission at hand—or even in the treasures to be won—than he is in the thrill of battle, in cheating death, and in living to the fullest. This character gives us another example of an action pose, only this time the figure has a smaller, trimmer physique than our bulky barbarian. Nevertheless, we're using the same bag of tricks to create action and dynamism. His body is lunging forward, and his legs are bent. He's even got one arm behind him as the other thrusts forward with his weapon. One significant addition to this character (which our action-posed barbarian lacks) is his rather elaborate costume. A cape that flies and swirls around the character's body is an ideal element for emphasizing the feeling of movement. When you draw this guy, be sure to get that cape really flaring out around him. You will be surprised how much this can add to the sense of life and action you are striving for.

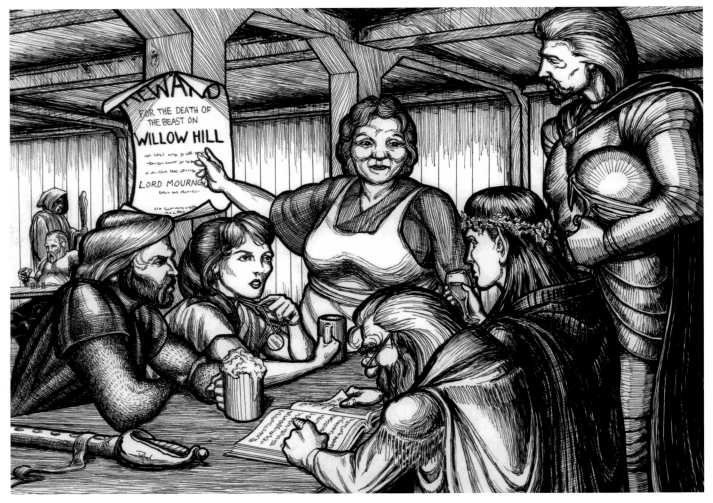

Meeting at an Inn
A woman innkeeper hires a group of adventurers to take on a very dangerous mission. (Art by Jeff Fairbourn.)

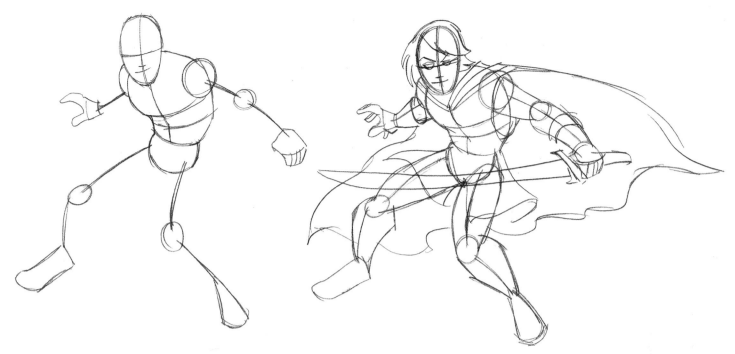

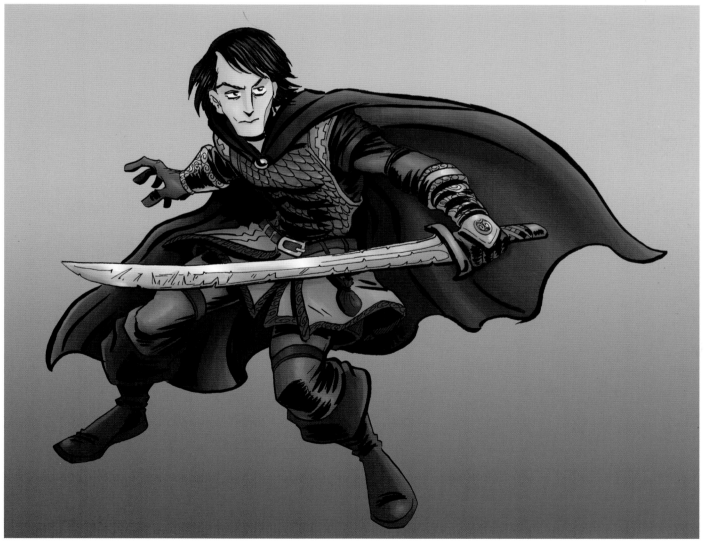

KNIGHT

Proud to serve as a soldier under a great king, the knight is a man of action by profession. Expertly trained in the arts of war by the best fighters in the land, the knight is absolutely fearless and unquestioningly loyal. He is fully prepared to go into battle at a moment's notice, and he is more than willing to risk his life to protect his kingdom.

The fun, and the challenge, of drawing this character is, of course, all that armor. The best way to tackle the armor is to forget about it—at least for a little while. Draw this character (and other heavily costumed characters) in two steps: First, nail down the basic human figure. There is a person underneath all that metal, after all, and if you don't get him down on paper first, you run the risk of making that suit of armor come out looking wonky and ill-proportioned. Besides that, it's easier this way. By this point, you've already got a handle on drawing human figures, so rather than confuse yourself by trying to draw a human figure in the shape of a suit of armor, just draw the human figure first, in the pose you want, and then draw the suit of armor on top of that figure. This approach will save you a lot of headaches and frustration. As for the armor, it's a simple combination of layered shapes. In fact, most of them are simple rectangles, which I'm sure you mastered back in kindergarten. All you have to do is to layer them and arrange them correctly around your basic figure.

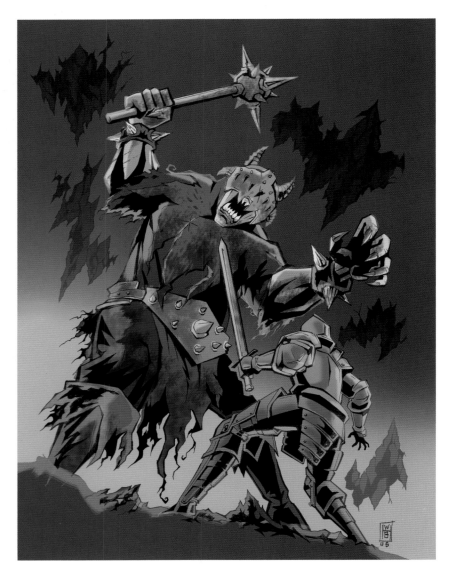

Knight versus Troll
A brave knight goes up against a troll in full battle armor in this thrilling scene. (Art by Bill Bronson, colors by Bryan Baugh.)

A knight's sword and mace. (Art by Bill Bronson.)

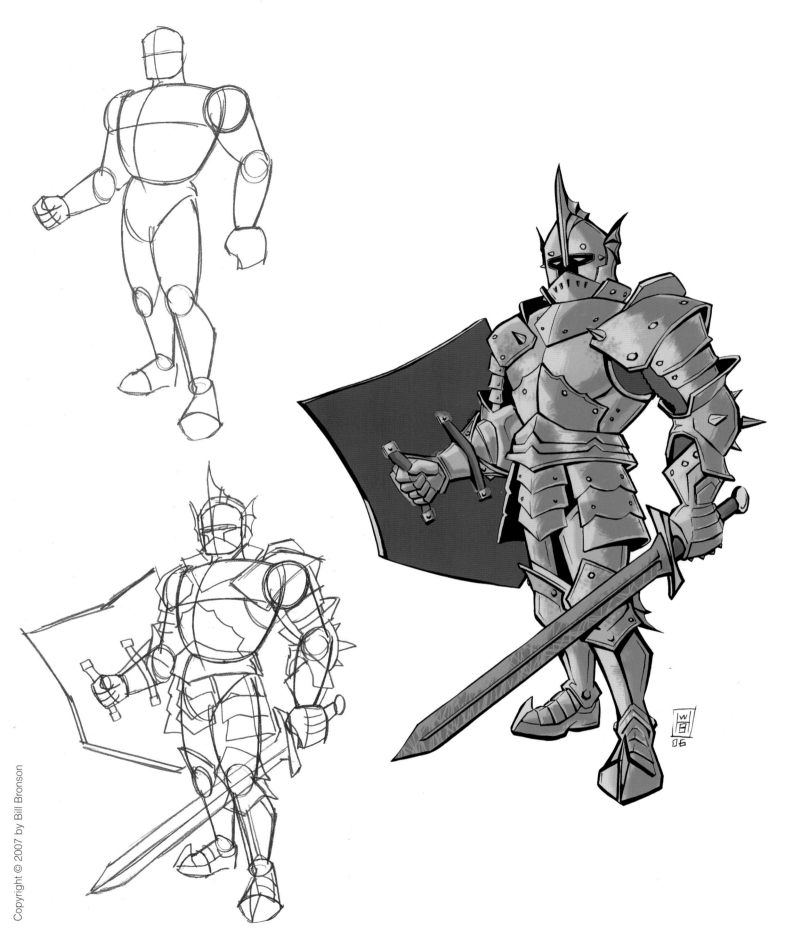

GREAT KING

He might be the ruler of a kingdom, but this king is not satisfied directing his troops from the throne room. When there is a battle to be fought, he puts on a suit of armor, picks up his sword, and heads out to the battlefield with his men. When drawing the great king, give him a tall, proud stance. Notice how straight his posture is, with chest thrust out and head held high. In his suit of armor, he presents you with a challenge similar to that posed by the knight. You'll want to approach the task in the exact same way, by drawing the basic figure first, then building that armor—and the great king's other adornments, including his helmet and cape—on top of the figure.

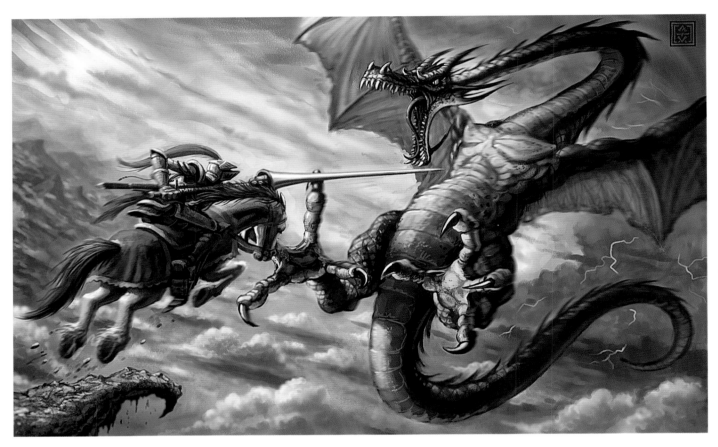

Leap of Faith
A knight and his steed launch a death-defying attack on a dragon. (Art by Adam Vehige.)

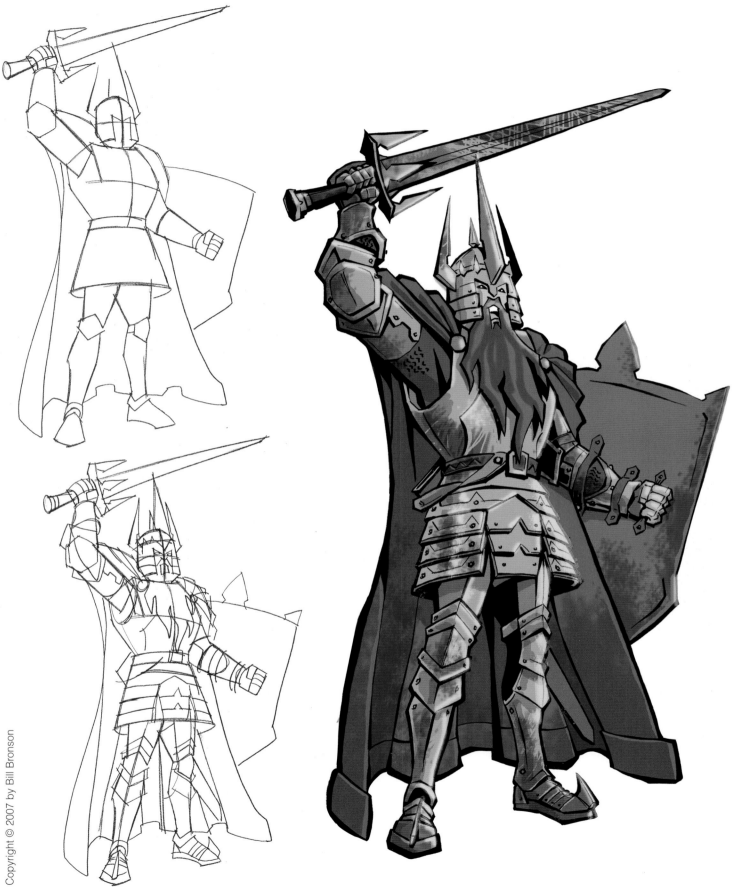

WIZARD

A master of mystical powers and magic spells, the wizard may work in the employ of a king or may serve no one but himself. With potions to heal ailments and supernatural wisdom that enables him to know things that others cannot, he prefers to use his extraordinary gifts to help others and for the greater good. If, however, he is given reason to turn his powers against an enemy, he can become a deadly, nearly invincible opponent. With nothing more than a whispered spell he can transform his enemy into a frog or blast him to oblivion with a bolt of devastating magical energy.

The wizard presents a totally different sort of figure-drawing challenge from those we've dealt with up to this point. No hulking barbarian, armor-suited knight, or trimly muscular swashbuckler, the wizard is a skinny old man. Stretch his arms, legs, and body into long, narrow shapes, and have fun exaggerating his tall, lean figure.

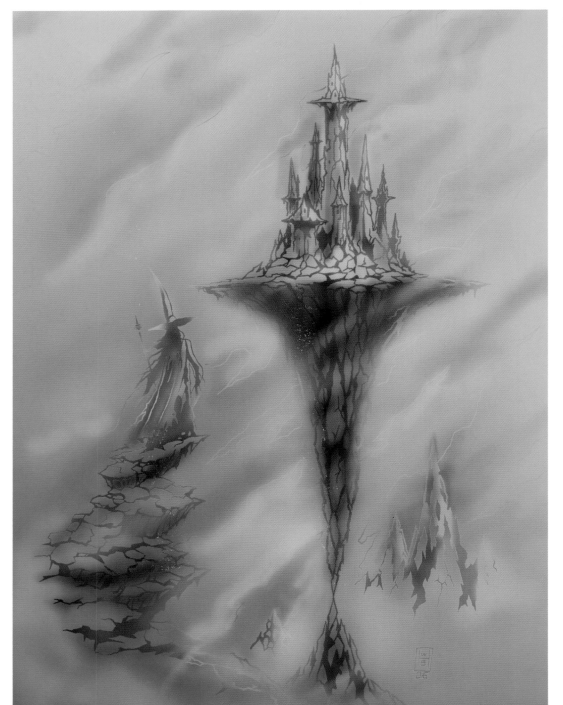

Sky Castle
A wizard uses his magic to travel to a distant, mysterious, floating castle in this impressionistic rendering. (Art by Bill Bronson.)

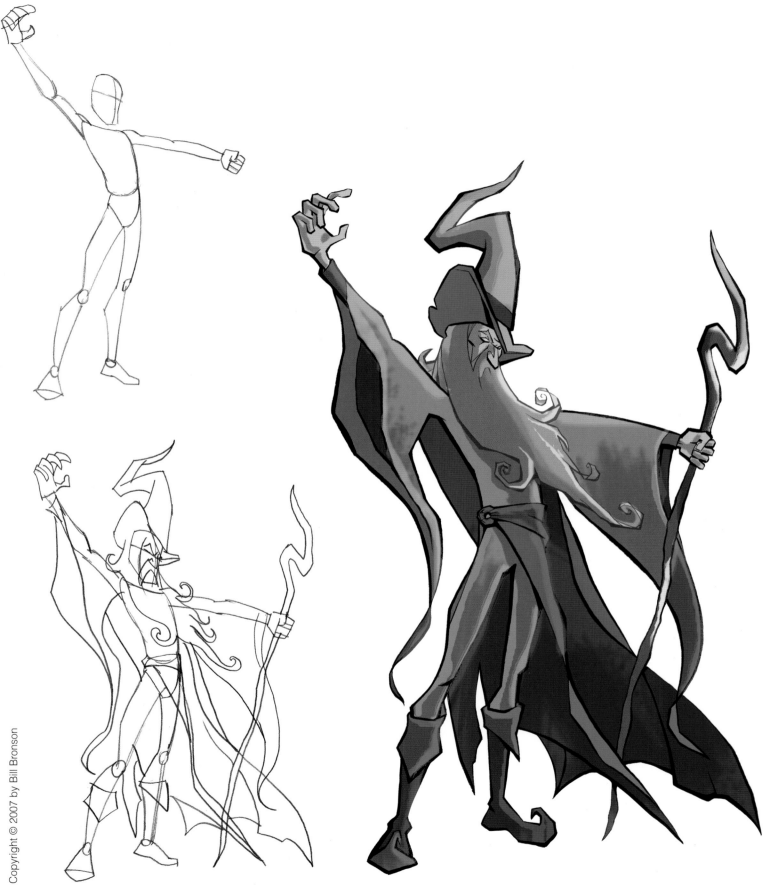

ELF

One of the most prominent intelligent races in the fantasy genre, elves are people of nature, building their elven cities deep within the forest. Elves are eternal beings, meaning that, unless they are killed in battle, they are capable of living forever. Although they are friends of mankind, elves generally keep to themselves and prefer to stay hidden in the secluded tranquility of the forest rather than mingling with other races. Drawing an elf presents a challenge similar to that of drawing the swashbuckler. Here is another character with a small, trim, but muscular build. This elf is posed for action, with his body bending forward and his cape flaring. The figure also offers a lesson on how to position the arms when a character is holding a bow and arrow.

Portrait of an Elf
The facial features of elves are naturally long and narrow. (Art by Bryan Baugh, colors by Zach Hall.)

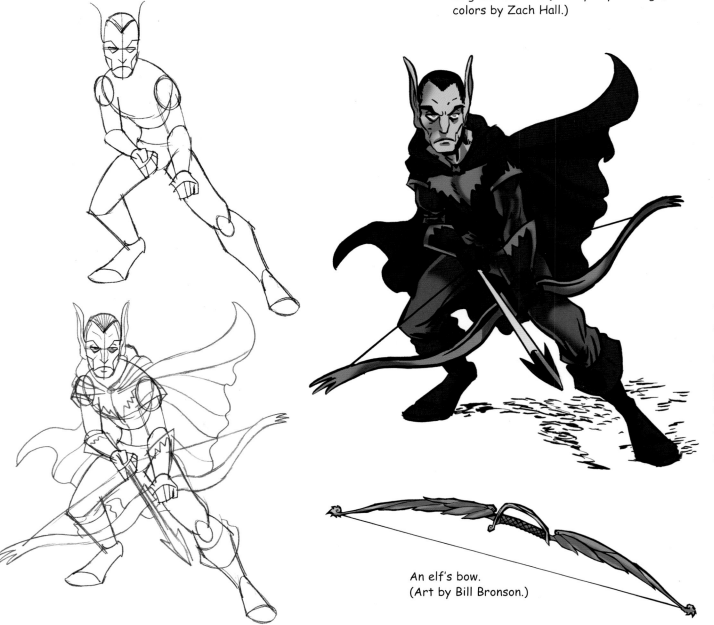

An elf's bow.
(Art by Bill Bronson.)

ELF WARRIOR

Despite their dedication to peace, elves must sometimes fight, and on such occasions they can prove to be ferociously deadly warriors. Incredibly quick and agile, elves are masters of swordplay and archery. Because of their elven metabolism, they also display stamina far beyond that of other races, and they can keep fighting energetically long after their opponents have grown weary. When drawing your elf warrior, keep him tall, thin, and graceful looking. He is neither a thick-muscled barbarian nor a towering, skinny wizard. He is somewhere in between, and his anatomy must display the difference.

An elf's spear.
(Art by Bill Bronson.)

An elf's axe.
(Art by Bill Bronson.)

DWARF

Short in stature but gigantic in spirit, dwarves have small, stout bodies and thick hair. Dwarves are miners by nature, and hard-working dwarf communities have been known to carve expansive underground cities right out of the solid rock of mountains. Despite their small size (they're about three to four feet tall), dwarves are incredibly brave, and they make for extremely tough, resilient warriors.

 Don't let this little guy intimidate you. Drawing him is really no different from drawing a normally proportioned human figure. There are just a few changes you will need to make. The most significant difference is the size of the head, hands, and feet in comparison to the size of the body. The relationships between the limbs, torso, and abdomen are the same for a dwarf as for a human figure, but a dwarf's head, hands, and feet are larger in comparison to his body. This may sound somewhat complicated, but it's really not. A helpful hint: as with the knight, you will have an easier time drawing the dwarf, and figuring out his odd anatomy, if you draw his basic body structure (sans costume) first. Then, after you've got that nailed down, add the costume on top of it. You will be less likely to get confused or make mistakes if you don't try to tackle both challenges at the same time. And the dwarf's costume, much like the knight's, is simply a series of squares and rectangles layered on top of the basic body structure.

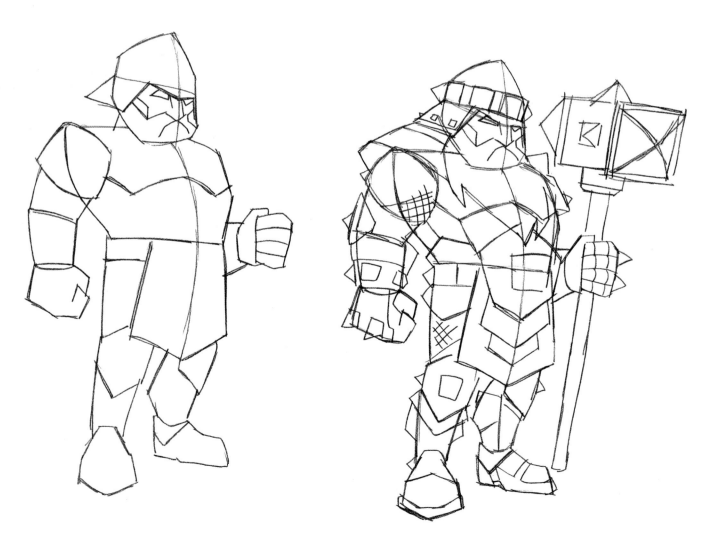

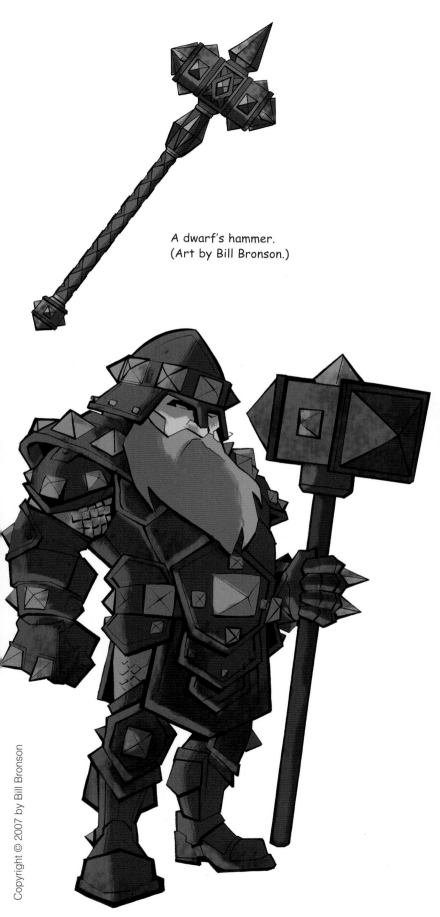

A dwarf's hammer.
(Art by Bill Bronson.)

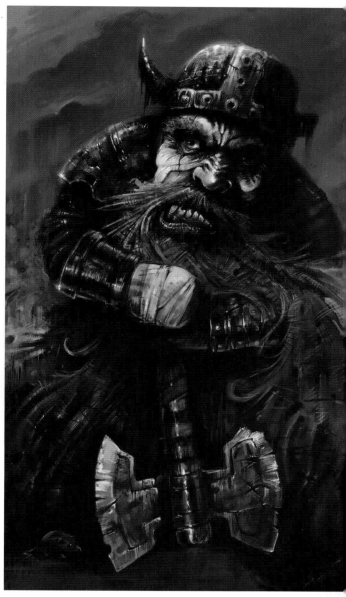

Portrait of a Dwarf
This grizzled dwarf warrior is certainly
tough looking. (Art by Grzegorz Krysinski.)

Seductive Heroines

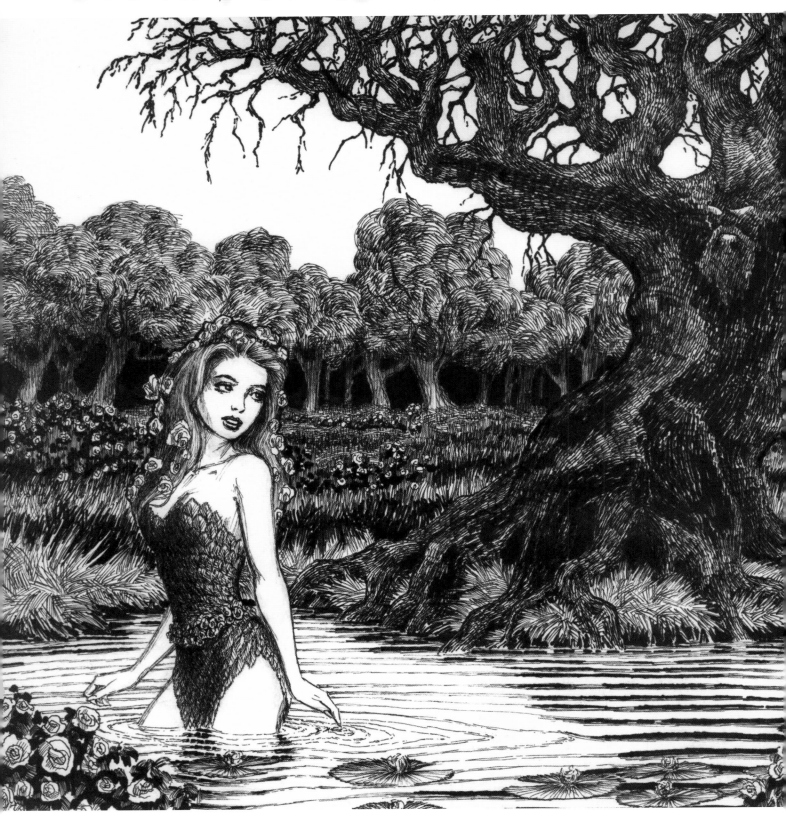

*O*K, LET'S TALK ABOUT DRAWING GIRLS. Let's face it, a lot of fledgling comic book artists, still learning their craft, find girls hard to draw.

You spend so much time struggling to master the anatomy and muscle groups of all those dynamic, bulky heroes that you tend to leave the opposite sex on the back burner. After all, guys like Batman, Conan the Barbarian, and Wolverine (from *X-Men*) are a lot more fun to draw than Wonder Woman. And the truth is, they're easier to draw, too, because you don't have to worry about making them look pretty. In fact, the rougher and grittier you make most male characters, the more interesting they become.

During the early stages of a hopeful comic book artist's training, learning to draw girls remains a distant goal, like an unmotivated, overweight person's resolution to join a gym and get in shape. It's something you keep telling yourself you need to do—something you tell yourself you will do eventually, just not today. Maybe it seems too hard, or maybe you're afraid of really trying and finding out that you can't do it. Or it may be something you've attempted, expecting to have no problem—after all, look how good you are at drawing all this other stuff!—and then were surprised, maybe even scared off, when you discovered how difficult it was.

So you deal with that failure and rebuild your confidence by going back to your superheroes, robots, and monsters. Every once in a while you might try drawing another pretty girl, but it never quite works. You're always bitterly disappointed with the results. And still there's that nagging voice in the back of your head saying, "You know, you can't get away with this forever. One of these days, you're going to have to start learning how to draw girls or you'll never make it as an artist."

I probably don't have to tell you this, but the nagging voice is right. You do need to learn to draw girls. And why run from it? It's not just a matter of being a better artist—it's part of the job. Female characters are essential to the kind of fantasy adventures we're dealing with here. Story-wise, they offer romance as well as tension. Visually, they offer sex appeal. They make your hero more interesting by giving him someone to fight for—or fight *with*, for that matter. And in some cases they grab center stage and become the heroes themselves.

The Nymph and the Evil Tree
In the fantasy world, there is always the threat of danger. This drawing shows how, even during a seemingly tranquil moment, evil may be lurking. (Art by Jeff Fairbourn.)

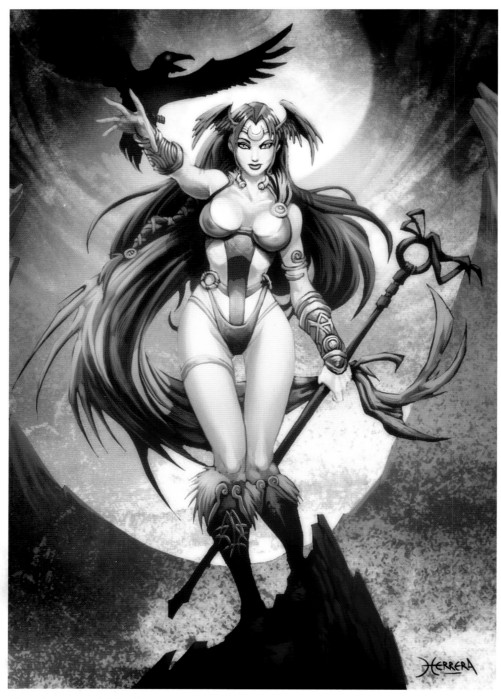

Morrigan and Hechizera
The female warriors Morrigan (above) and Hechizera (right)
are striking and voluptuous. (Art by Mauro Herrera.)

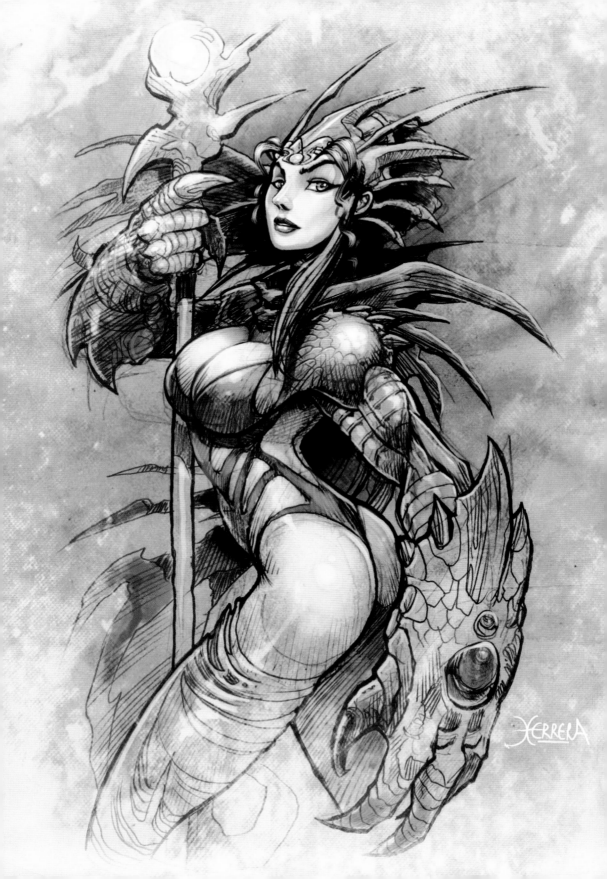

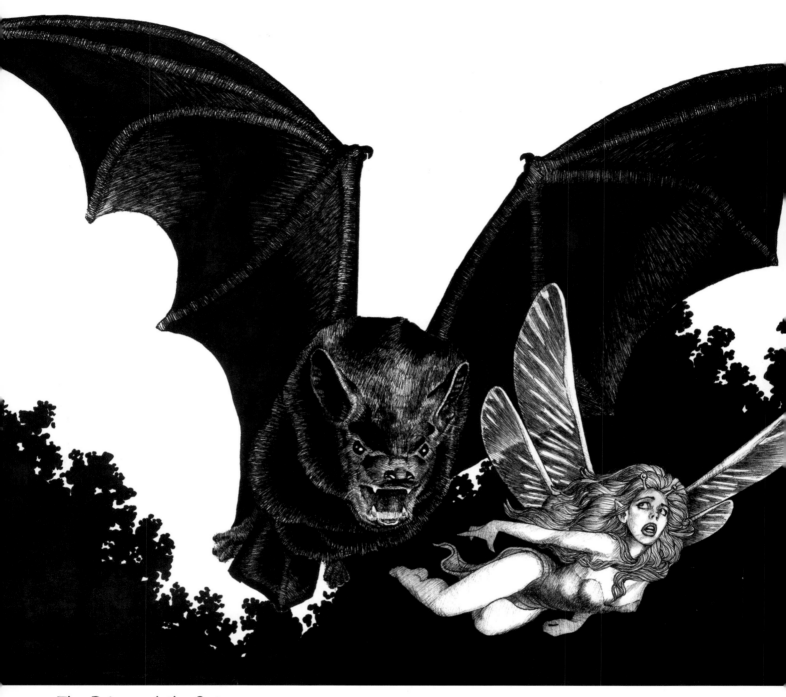

The Fairy and the Bat
A tiny fairy suddenly finds herself in a very bad
situation. (Art by Jeff Fairbourn.)

If you yearn to add beautiful female characters to your repertoire but have been struggling with how to draw them, I have some good news for you. Drawing girls is not as impossible as it might seem. It just takes a lot of practice, a slightly different approach from what you may be used to, and a certain amount of artistic restraint, which is something I'll explain in a moment. Once you start to get the hang of it, you'll find that drawing girls can be as much fun as drawing hard-edged heroes, robots, and monsters. Well, OK, maybe not as much fun as monsters, but close.

The key to drawing attractive women is extremely simple. It's one of those things that's so obvious that it's easy to miss: the whole time you're drawing them, you just have to keep in mind that women are the opposite of men. Therefore, every step you take will be the opposite of what you would normally do when drawing a male character.

Your basic process is, however, the same. Approach the drawing of a female character the same way you would approach the drawing of a male character—building her up with basic shapes, defining her form, getting her pose right, and getting all the proportions to work together. But while doing this, you want to invert all those lessons about drawing heroic male characters that have been burned into your brain. Instead of broad shoulders, a female has narrow shoulders. Instead of narrow hips, a female has wider hips. Instead of hard-edged lines and sharp contours, a female character is going to have smoother, flowing lines and rounded edges. You want curves instead of corners, in other words.

This principle becomes even more crucial in the finishing stages of your drawing. One thing you may have discovered about drawing male characters is that the more line work and surface detail you put into them, the better they look. If you do it right, wrinkles and shading techniques can add a lot of personality to your male characters. The natural assumption is that the same approach should work when drawing female characters. But in this case, less is more. Too much cross-hatching and line work on your female characters will leave them looking rough and mannish. I'm not saying you shouldn't apply these techniques at all. I'm just saying that you should keep them to a minimum. If you do, you will notice your female characters looking a lot softer and smoother.

It may go against everything you've picked up while learning to draw superheroes, but we're not drawing superheroes now. We're drawing the heroine, and you don't have to shade and define every muscle of her body to make her look real. Force yourself to define her whole body by her outline, using only a very limited number of lines around the joints, where movement, and thus wrinkles or folds in the skin, naturally occurs. And keep your lines as smooth as possible—that makes a big difference, too. Try not to allow scratchy edges or excessively rough lines.

In the world of comics, art that is rich in detail and heavy on line work and texture is always celebrated, always encouraged. And for the most part, that's great. But in this one facet of comic book art—the idealized female character—you may find that less surface detail equals better results.

Swamp Elf
This pretty female elf has chosen to dwell—or perhaps just to play—in a lush green swamp. (Art by Bill Bronson.)

PRINCESS

Just because she is the daughter of the king does not mean this princess lounges around the castle being waited on by servants all day long. Bored with treasures and luxury, she has an eager interest in the thrill of adventure, and she sneaks out of the castle to embark on her own escapades whenever possible. Keep the princess's figure small and thin, so she appears to be a lightweight, agile fighter.

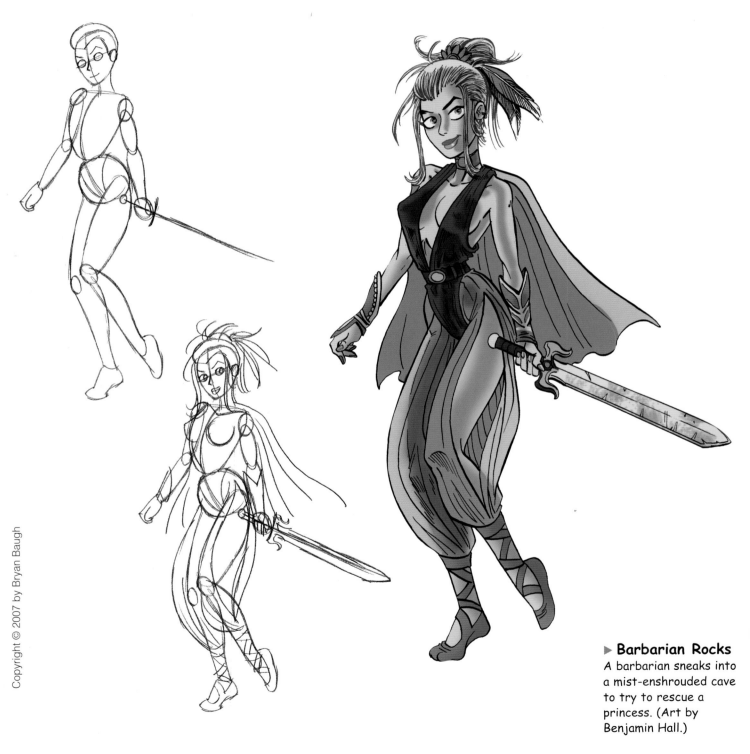

▶ **Barbarian Rocks**
A barbarian sneaks into a mist-enshrouded cave to try to rescue a princess. (Art by Benjamin Hall.)

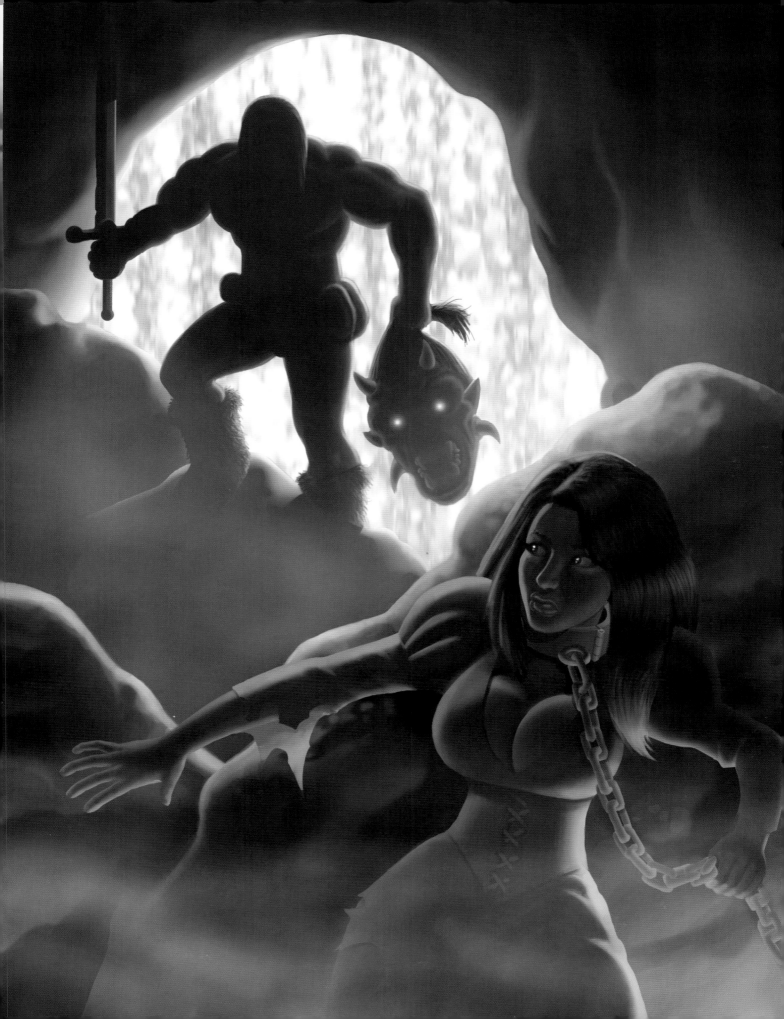

FEMALE ADVENTURER

The female equivalent of the barbarian, this adventurer is a traveling woman-warrior who moves from place to place, risking her life to recover lost treasures, battling evildoers, rescuing captives from enemy strongholds, and taking on other dangerous assignments from those who can offer her the best pay. Every bit as tough as she is beautiful, the female adventurer stuns enemies with her looks, then strikes them down with her sword. A fierce fighter and a loyal companion, she is desired by all men—but few are up to the challenge. This girl has a slightly taller, more muscular build than the princess, but she isn't thick or brawny. Make her slim and athletic while keeping her strong and bold.

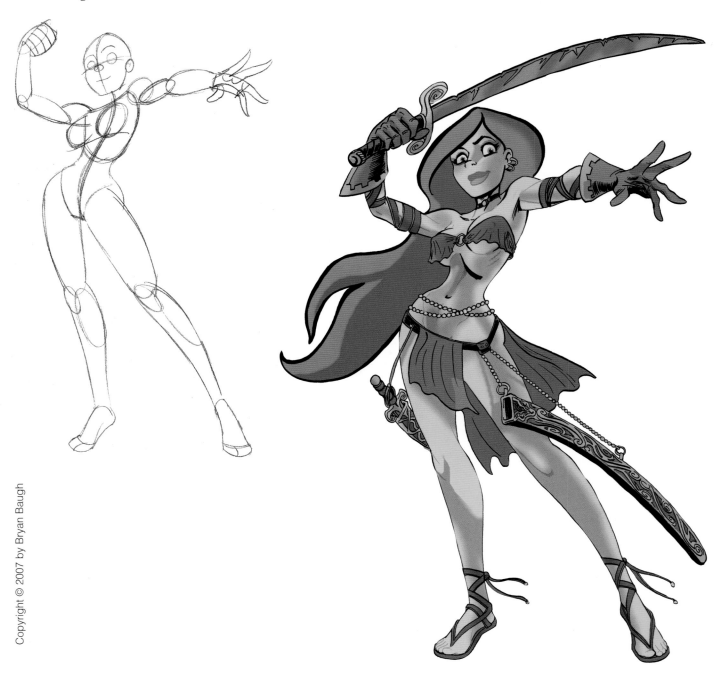

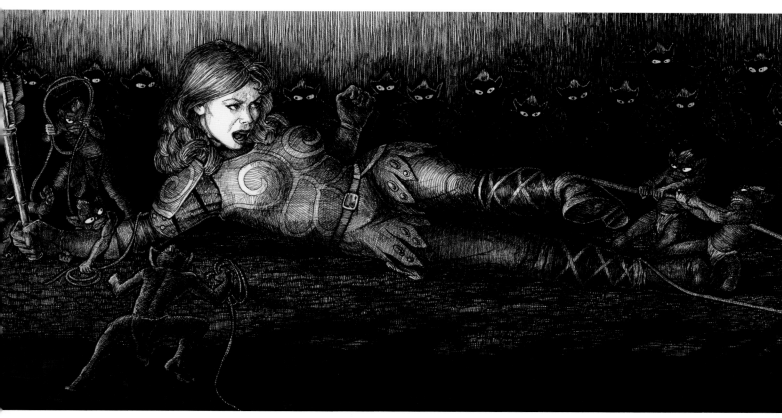

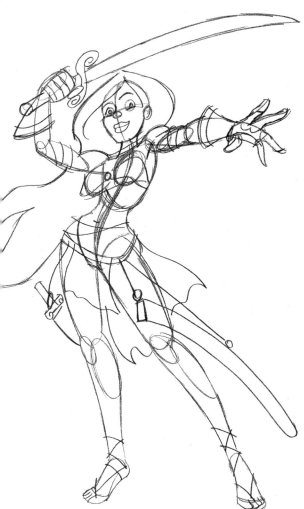

Rats in the Cellar
A female adventurer finds herself captured by a horde of dreadful little monsters. (Art by Jeff Fairbourn.)

VALKYRIE

The fierce female warriors known as the Valkyries are inherently good in nature and serve only the most benevolent, morally correct kings and rulers. The Valkyries' origins are shrouded in mystery. Some legends describe them as a society of very tall and powerfully built human women whose culture revolves around the arts of war. But in other stories the Valkyries are actually a race of immortal deities who work directly for Odin, the leader of the Norse gods. According to these myths, it is the sacred duty of the Valkyries to transport the souls of great warriors who have died in battle to the afterlife. It is also said that the armor and weapons used by the Valkyries are blessed with supernatural power, making them indestructible.

Valkyrie Warrior
The Valkyrie is strong, courageous, and beautiful—all warrior, and all woman. (Art by Dave White.)

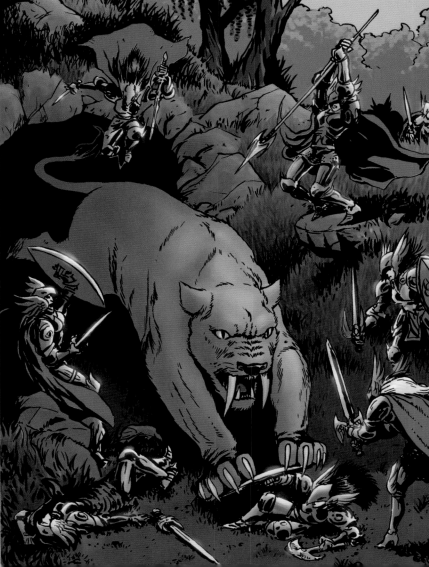

Valkyries versus Saber-tooth
A tribe of courageous Valkyrie warriors struggles to bring down an unstoppable saber-toothed cat. (Art by Dave White, colors by Benjamin Hall.)

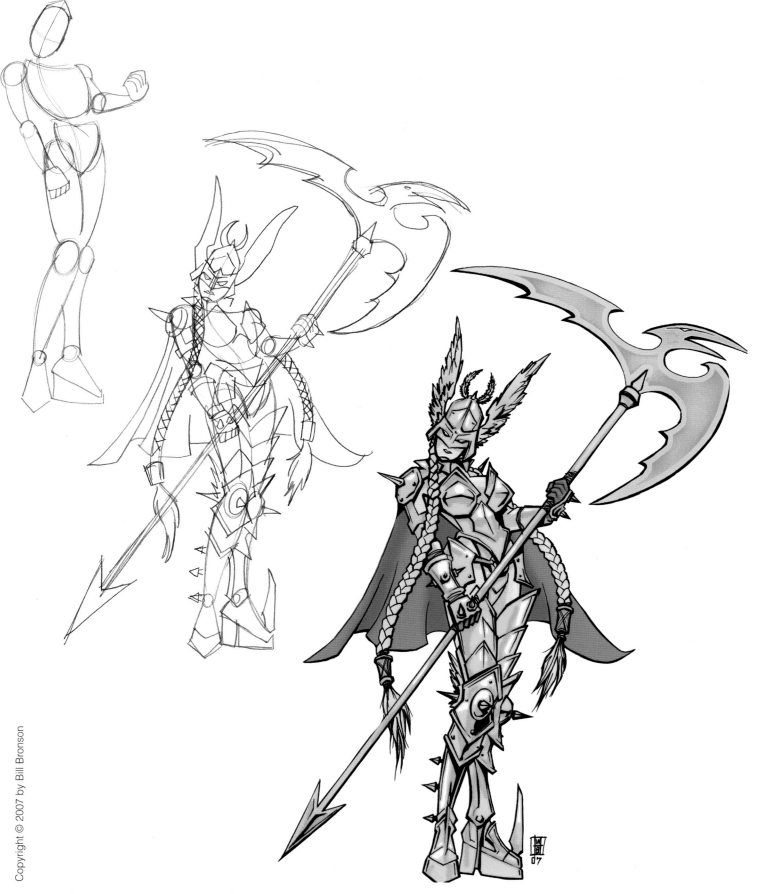

SORCERESS

This mysterious female magician has dark leanings toward occult practices, but she is not truly evil. Her ways are strange and her powers are frightening, but she chooses to work in the service of kings, queens, and other noble leaders. Her magic is most frequently called upon to foresee—and then to influence—conflicts with belligerent nations, as well as to cast spells on those enemies who are getting out of hand. Years of meddling with weird magic have caused her to lose the natural, human need for companionship, so she seeks no man to love her. Instead, she spends all her time in her rooms, down in the darkest depths of the castle, scouring ancient spell books, seeking only to increase her arcane knowledge and power. If she's not careful, she could turn into a witch as she grows old. Obviously, the most striking thing about the sorceress is her elaborate costume. Follow the lines shown in the step drawing to figure out the construction of her strange headdress and gown. But take note that under this garb she is still a normally proportioned female character. You may want to start out by drawing her basic figure, and then add the adornments on top of it.

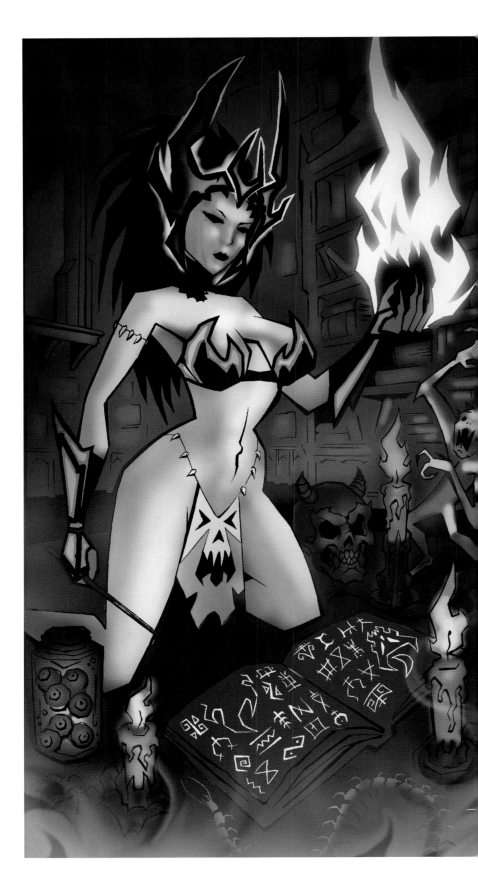

The Sorceress's Library
In her secret lair, a sorceress conjures another powerful spell. (Art by Bill Bronson.)

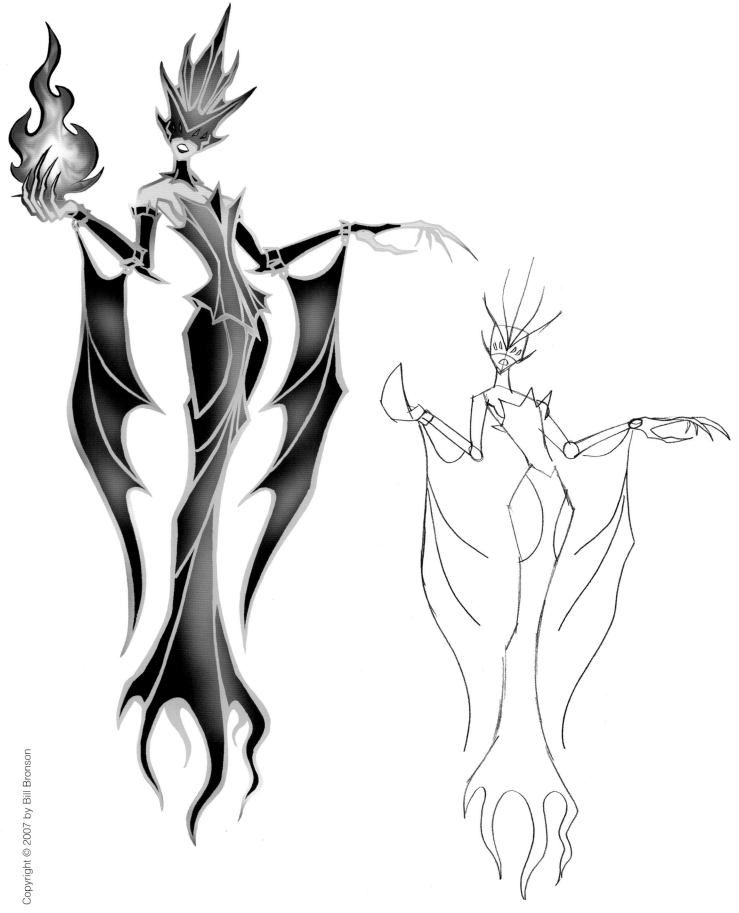

THIEF

A lower class of female adventurer, the thief frequents the streets of cities and villages, always on the lookout for new opportunities to profit from, whether honestly or dishonestly. As her name implies, she is most talented at sneaking into castles, temples, tombs, and other strongholds and stealing whatever treasures may lie there. Here is another character whose most striking feature is her costume. As before, you will find that this character is easier to draw if you nail down the basic figure first, then draw the costume on top of it.

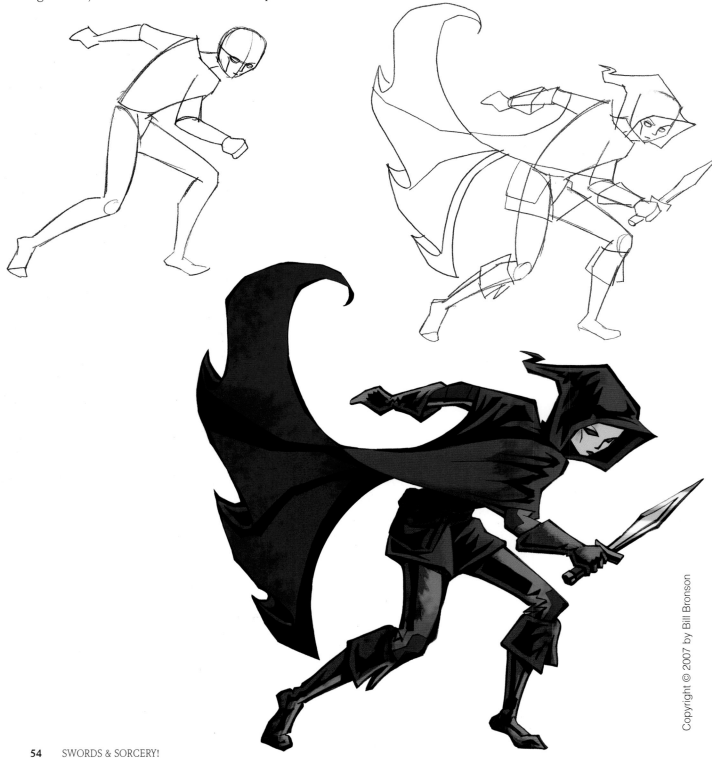

FEMALE ELF

In elven societies, the women are just as skilled and fierce in the art of warfare as are the men. If you've gotten a handle on drawing the female figure, and if you can draw pointy ears, you should have no problem with the female elf. The specific features that make her stand apart from other female characters—and that make her look elven, as opposed to human— are her arched eyebrows, high cheekbones, and long, narrow face. Proportionally, she is somewhat taller, longer, and thinner than a human woman.

An elf's sword.
(Art by Bill Bronson.)

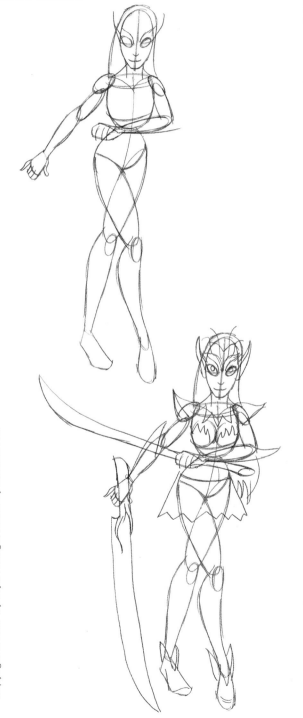

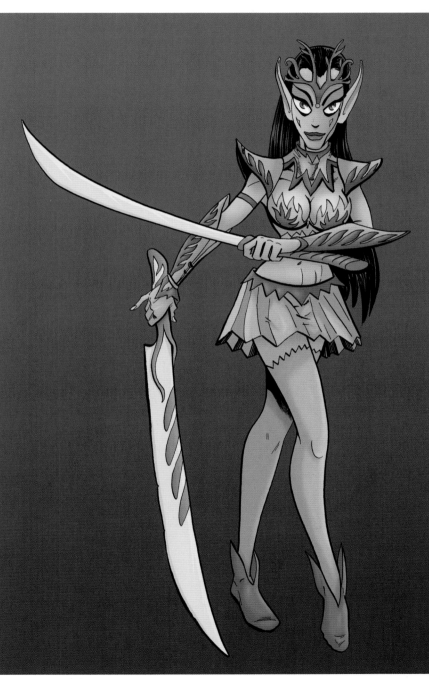

Dastardly Villains

SOME MEN ARE NOT AS NOBLE AS THE kings, knights, rangers, and elves described earlier. In this chapter, we enter the realm of the villains. From the lowliest savages and petty criminals to the most awesomely powerful sorcerers and bloodthirsty warlords, these individuals all have one thing in common: they possess no interest whatsoever in serving the greater good, making the world a better place, or helping those in need. Their only passion is to fulfill their own selfish goals of power, wealth, greed, and destruction.

Drawing evil characters requires a sensibility somewhat different from the strong, dynamic approach used when drawing heroes. For example, you will remember that when we talked about drawing the barbarian, ranger, and swashbuckler, we made a point of giving each character a bold, proud stance. But in most cases, the character of a villain will be conveyed most effectively if he is shown slouching or lurking. There are exceptions to every rule, of course, but the majority of these sinister, shadowy characters should have postures as bent and crooked as their personalities.

One of the fun things about fairy tales, myth, and the fantasy adventure genre is that the outward, physical appearance of characters offers a clear depiction of who they are on the inside. So feel free to make your villains look as ugly, scary, and unappealing as possible. Exaggerate arched eyebrows and snarling mouths, make eyes beam with hate, and make hands curl into clawed hooks. Adorn them in ragged, torn capes, dirty clothes, and scarred armor. Warp your imagination, and add details that will convince your viewer that these characters are truly dangerous and purely evil.

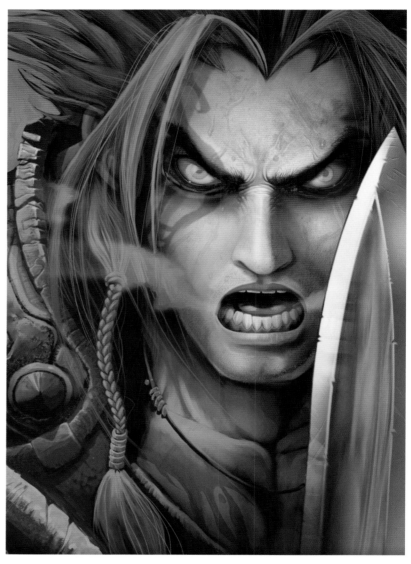

Berseker
The wild eyes of this wild warrior have a mesmerizing glow. (Art by Mauro Herrera.)

▶ **Naglfar Sails to the Doom of Gods**
The mythological Norse ghost ship *Naglfar* sails through the heavens on its way to do battle with the gods. (Art by Jeff Fairbourn.)

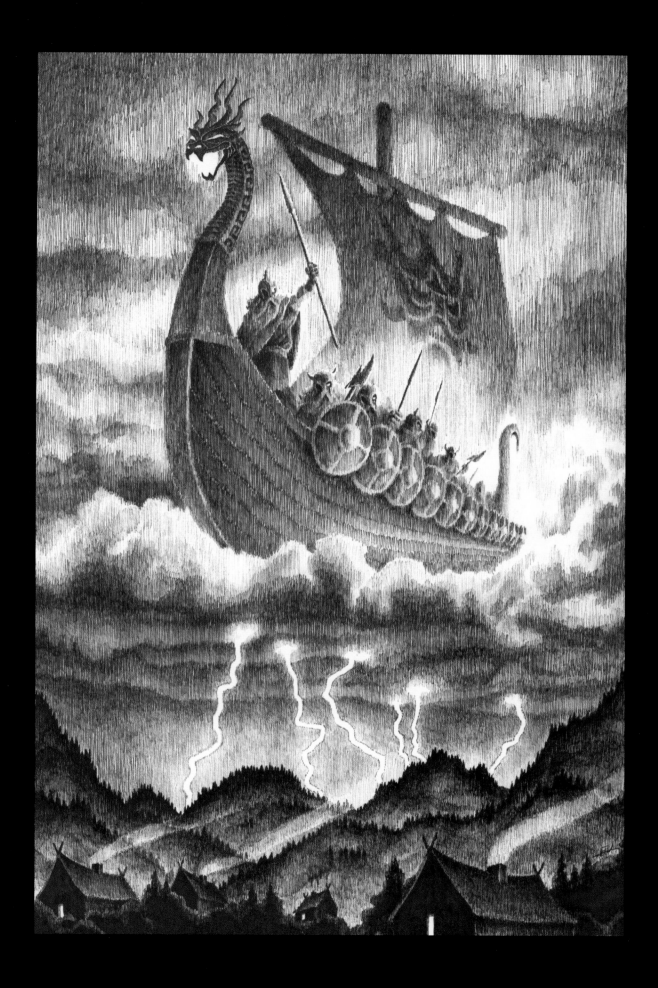

SORCERER

Although he possesses the same powers as the wizard, the evil sorcerer has no human compassion nor any interest in helping others. He is instead bent on his own selfish quests. His dark magic is only used as a tool to acquire more wealth and influence for himself—and to curse and ruin anyone he views as a threat. He sometimes works in the service of evil tyrants and warlords, lending his powers to help them win battles and kill their enemies. But his devilish skills come at a very high price. The evil sorcerer cannot be trusted: when it looks as if his employers may be losing the fight, he has a way of vanishing into the shadows, never to be seen again.

When drawing the sorcerer, you've got to make him look like the crooked old man that he is. His posture is slouching. His limbs are scraggly and thin. His hands are like claws. His eyes must display a look of madness.

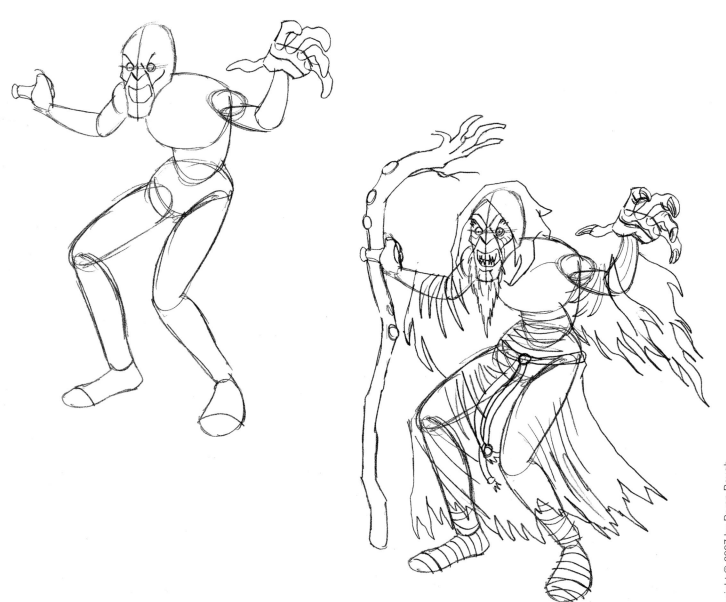

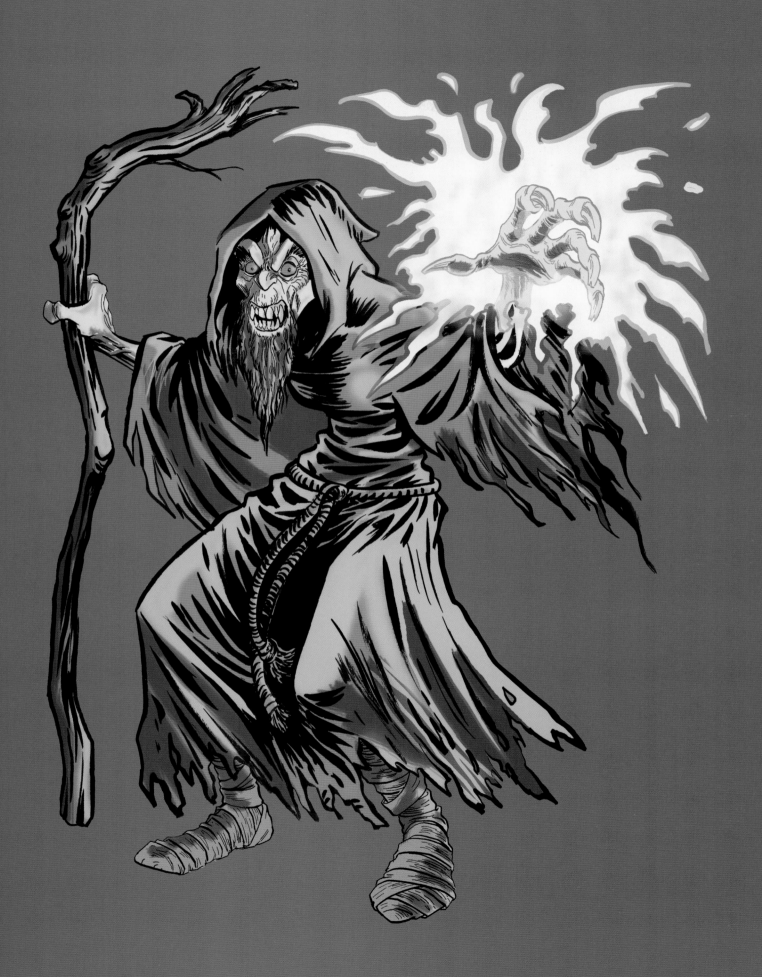

WARLORD

Slaughterer of men and conqueror of kingdoms, the warlord is a mysterious figure whose massive presence is outsized only by his reputation. Several simple tricks are at work in this drawing to give the warlord a more imposing presence. As with any powerful male character, his shoulders and chest have been made extra-wide while his waist has been kept narrow. Spreading his feet far apart gives him a solid stance and adds a feeling of weight. Flaring the cape also makes him seem more dramatic. But perhaps the most important thing about this drawing is the angle from which we view the character. Notice that our viewpoint seems to be somewhere below him—that we are looking up at him. It's a subtle difference, but it makes it seem as if the warlord is towering over us, which in turn makes him seem more powerful and dominating.

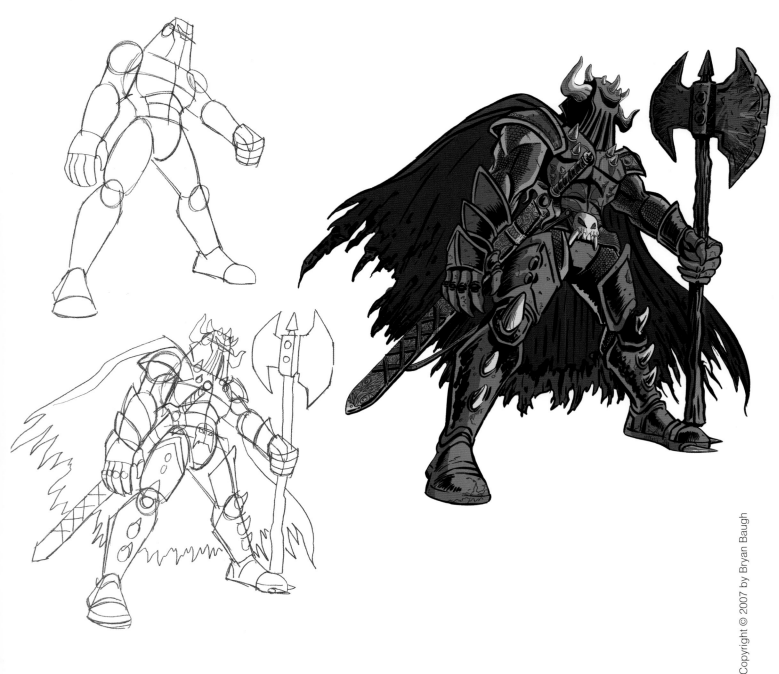

BERSERKER

Near-primitive tribesmen who live in the middle of dense forests, the savage berserkers pattern themselves on bears. Their entire lives—including their family structure and their fighting style—are modeled on bears' behavior. During the frenzy of battle, berserkers believe that they actually channel, and are empowered by, the spiritual energy of bears themselves. They normally stay hidden in their shadowy woodland home, but if you wander into their territory, you could be in for serious trouble. This character's pose is the key to his dynamism. Notice the exaggerated curve of his whole body as he swings that axe over his head and prepares to bring it down on his intended victim.

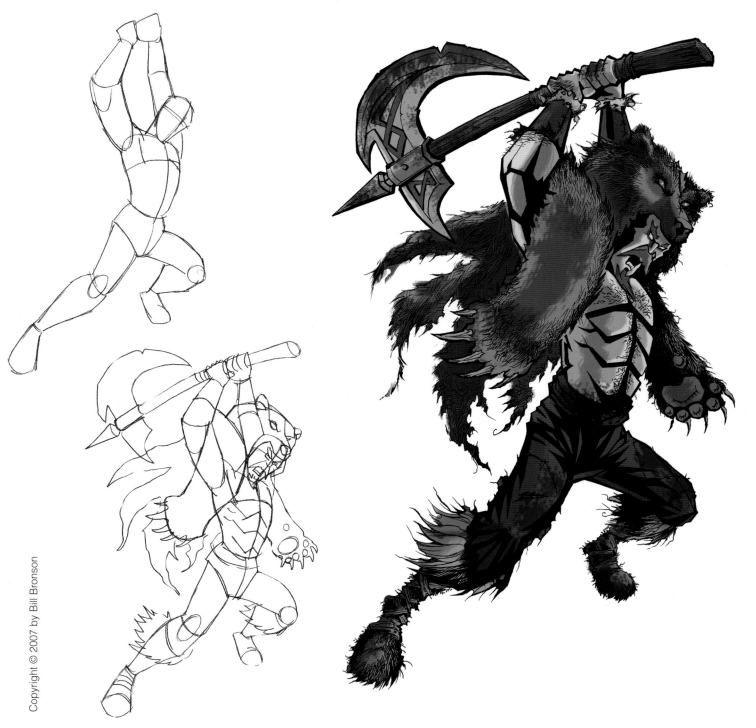

CANNIBAL

The most horrible breed of human beings, cannibals live in small tribes, hidden deep in the darkest forests and jungles. Woe to those who stumble into cannibal territory—or a cannibal trap. These bloodthirsty flesh-eaters believe that consuming the body of another human being will enable them to absorb that person's strength. They are always on the lookout for new victims. This cannibal is an unhealthy creature—not just evil but insane—so a strong, powerful posture would be inappropriate for him. Instead, we show him slouching, with his head set low on his shoulders, his knees bent, his shoulders slumped, and his spine slightly curved. We have also left his eyes blank. This simple omission of his pupils gives his face an expression of madness.

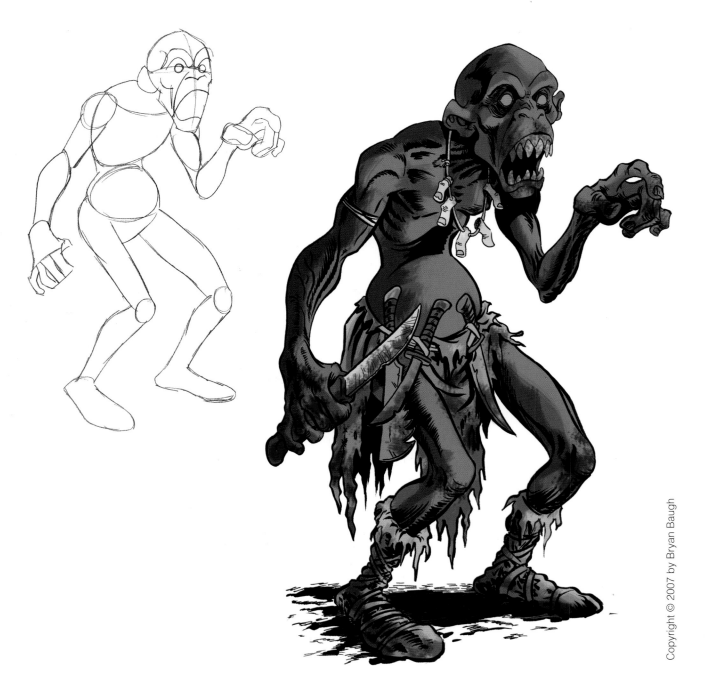

WITCH

These hideous old women are users of dark magic, casters of evil spells, conjurers of demons, and practitioners of murder and cannibalism. In certain situations, however, their skills can be very useful. Because of witches' ability to tell the future—and their voluminous, dark knowledge of secret things—brave heroes will occasionally seek them out to ask them for advice. Most witches are willing to cooperate and answer a few questions for a small payment, but this is still an incredibly risky mission. Whether the hero pays her or not, the witch will always try to catch him, kill him, and cook him for dinner. If the hero can avoid her clutches, though, he may escape the witch's foul lair with crucial scraps of arcane wisdom that will greatly benefit him as he pursues his goal.

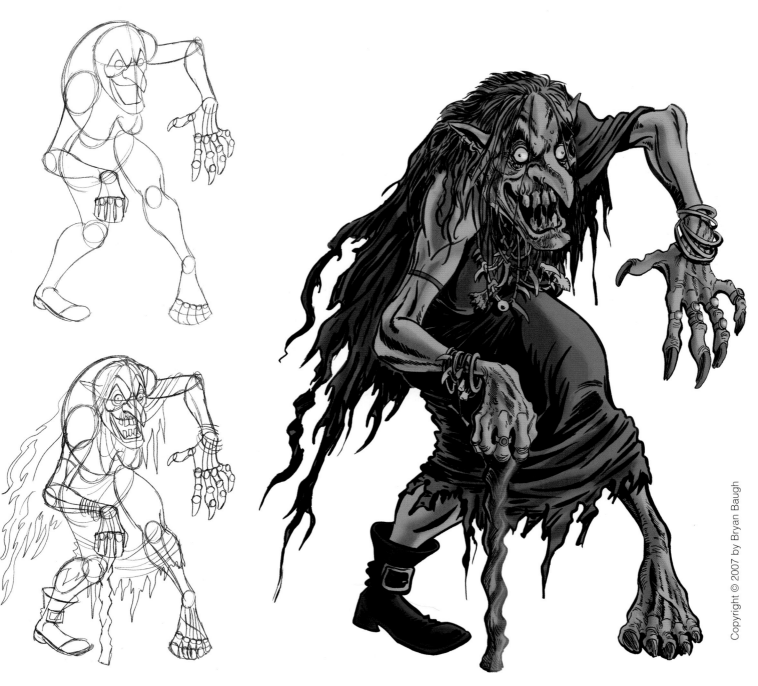

THUG

Tough little men who roam the alleys and streets of crime-ridden villages, thugs have no moral scruples whatsoever. If possible, they will use trickery to con others out of money or goods, but they are not above mugging their victims with brutal force. Thugs are known to occasionally work as spies or hired assassins for sinister employers, but they are too shifty to stay with any job for long. They are happiest when living and working anonymously for themselves alone. As with the dwarf, the secret to drawing the thug has to do with his proportions. To make him look small, you'll want to keep his head, hands, and feet relatively large in comparison to his body. Unlike the dwarf, however, the thug is far from heroic, and you can emphasize his evil, corrupt nature by giving him a hunched, slouching posture.

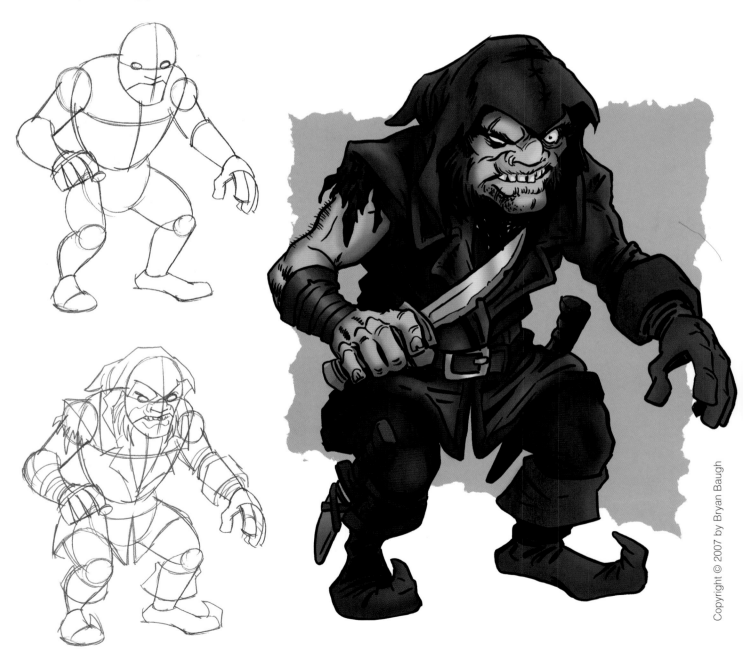

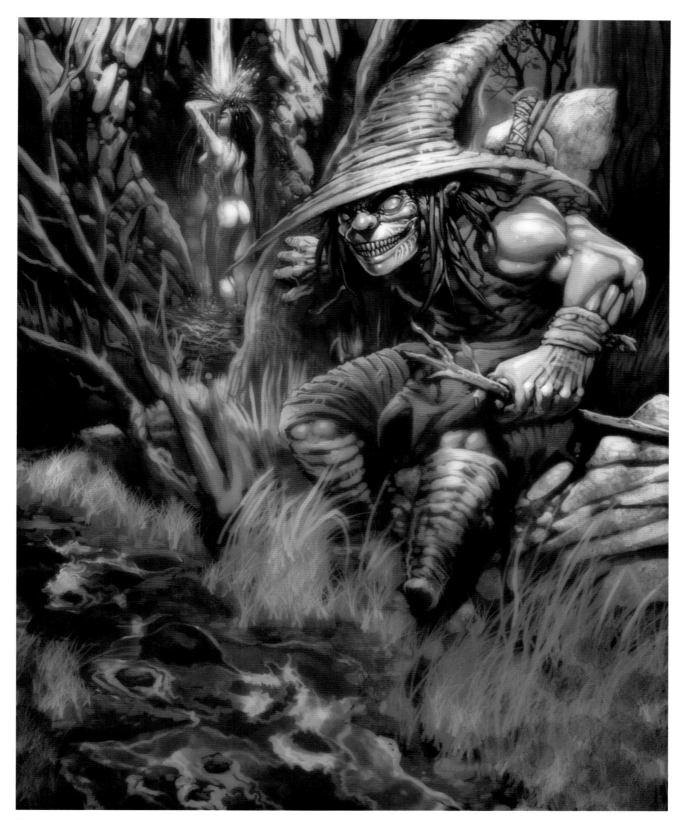

El Trauco
It looks as if this mischievous thug is about to
rob a very vulnerable victim in this risqué scene.
(Art by Mauro Herrera.)

Goblins, Orcs, and Their Wicked Kin

W̱E HUMANS, AND OUR ELVISH AND DWARVISH COUSINS, are not the only intelligent beings who populate the fantasy world. In the bowels of caves and the shadows of mountains, there exist other races of thinking creatures. Among them are the goblins, the orcs, the trolls, and the ogres. These are the evil ones, the monsters who would overrun the world of men and conquer it as their domain. These monsters hate us. They must not be pitied, tolerated, or sympathized with. They must be destroyed, or they will destroy us. For in their dripping dungeons and foul-smelling caverns they plot against us at all times. They want nothing more than to cleave human heads with their swords—to kill our men, eat the flesh of our women, and make slaves of our children. In this chapter, we will use many of the same basic lessons of figure drawing that we practiced in the last chapter. But here we will twist those lessons and add in healthy doses of imagination to create subhuman monsters who, though they may walk on two legs, have nothing else in common with us.

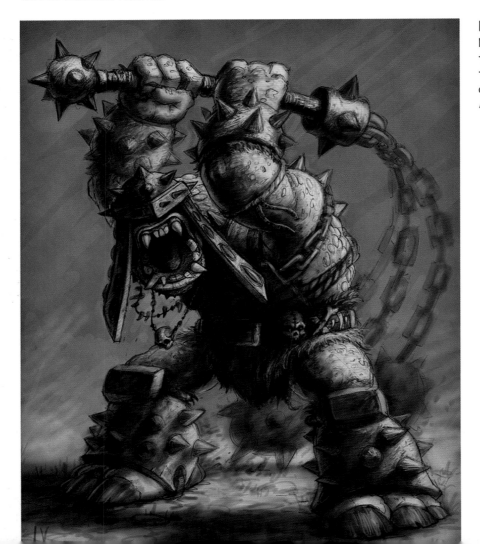

Battle Troll
Note the human skull trophies that decorate this battle troll's belt and necklace! (Art by Adam Vehige.)

Shush
Sneaking up on three giant trolls is careful work. (Art by Kerem Beyit.)

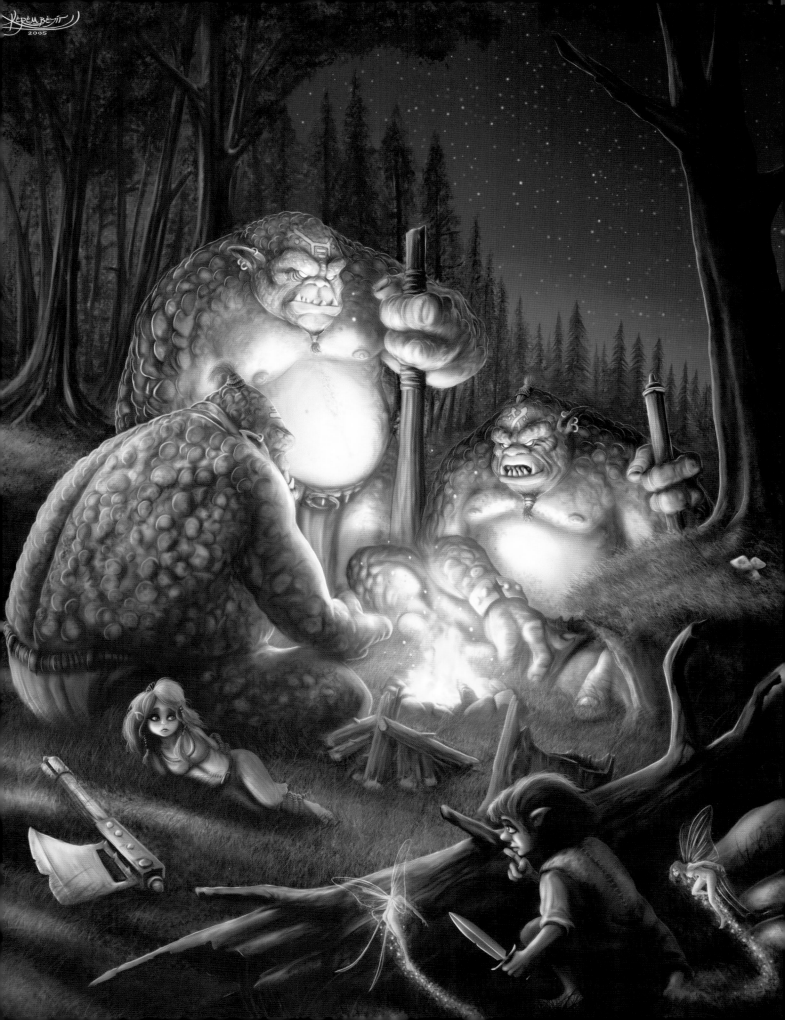

GOBLIN

Small, ugly, and only quasi-human, goblins are tiny relatives of the larger and far more dangerous orc races. Goblins are certainly evil, but usually they are more mischievous than malicious. They find great humor in ambushing, attacking, and robbing others for their own gain. They find even more humor in killing and eating those who wander into their territory. Sneaky and quick, with a penchant for destruction and mayhem, goblins are dangerous when alone and deadly in large numbers. The goblin's stature is smaller than that of any of the other characters in this book. You therefore have to pay especially close attention to his proportions, noting that the goblin's head, hands, and feet are even larger in comparison to his body than are the dwarf's or the thug's. Keep the goblin's limbs scrawny and malnourished looking. Have fun exaggerating his face with a long, crooked nose and big, pointed ears.

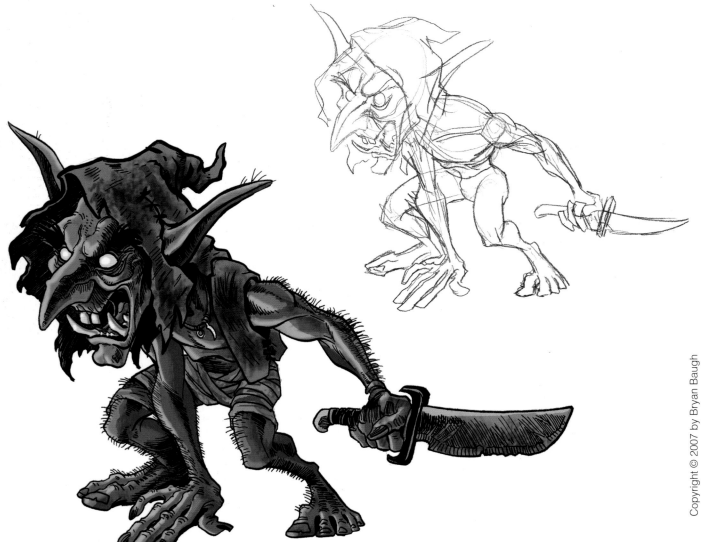

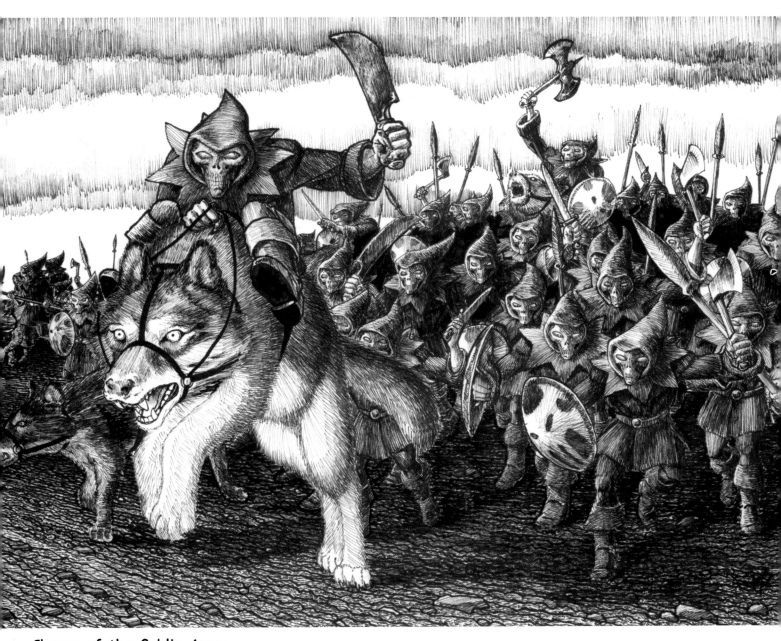

Charge of the Goblin Army
An army of goblins rushes into battle—some mounted on
wolf steeds. (Art by Jeff Fairbourn.)

The Well

Goblins make mischief while a mysterious figure observes from the shadows in this forest scene. (Art by Kerem Beyit.)

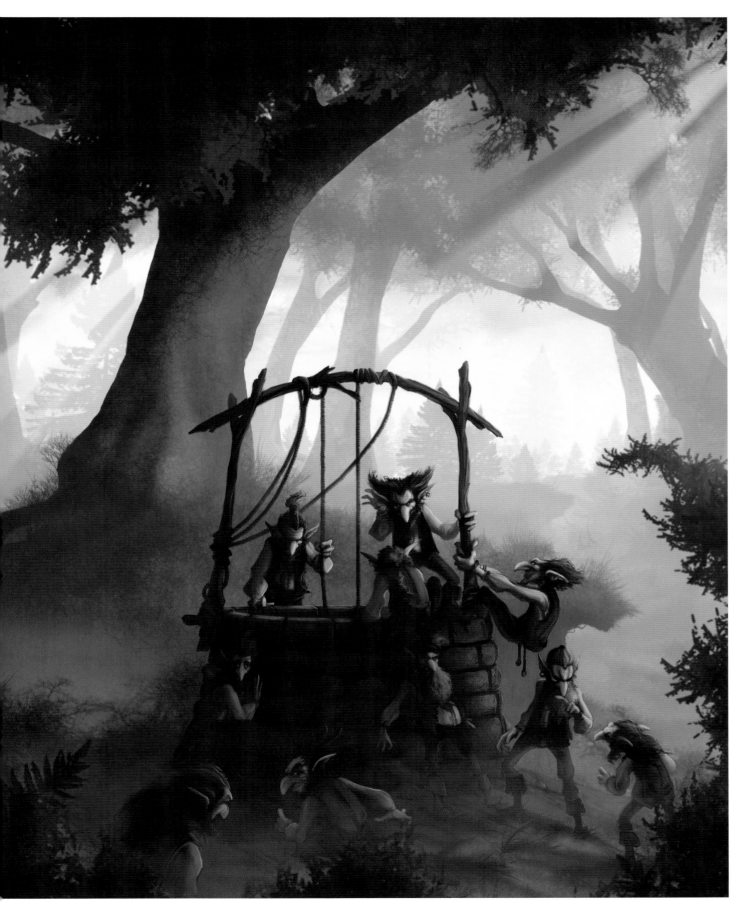

ORC

Orcs are among the most frightening, thoroughly evil creatures in all of fantasy. They are huge, towering over human beings at an average height of seven feet, and they are incredibly strong. What makes orcs even more terrible is that they are naturally warlike. They have a frenzied lust for the horrors of battle, a specific hatred toward mankind, and an overriding desire to exterminate humans and replace them as the dominant race in the world. Although orcs are wild, bloodthirsty creatures, their intelligence should not be underestimated. Orcs have language—both speech and writing—and they are sophisticated enough to construct elaborate, if somewhat crude looking, armor and weapons and to organize themselves into armies.

This orc's upper body—wide at both the chest and the waist—is heavily muscled. His head is slung low on his shoulders, and his limbs are thick. His slouching posture and inward-turning knees add a subhuman, demented quality to his overall appearance.

Portrait of a Scar-faced Orc
This orc is a particularly nasty specimen.
(Art by Bryan Baugh, colors by Marlena Hall,)

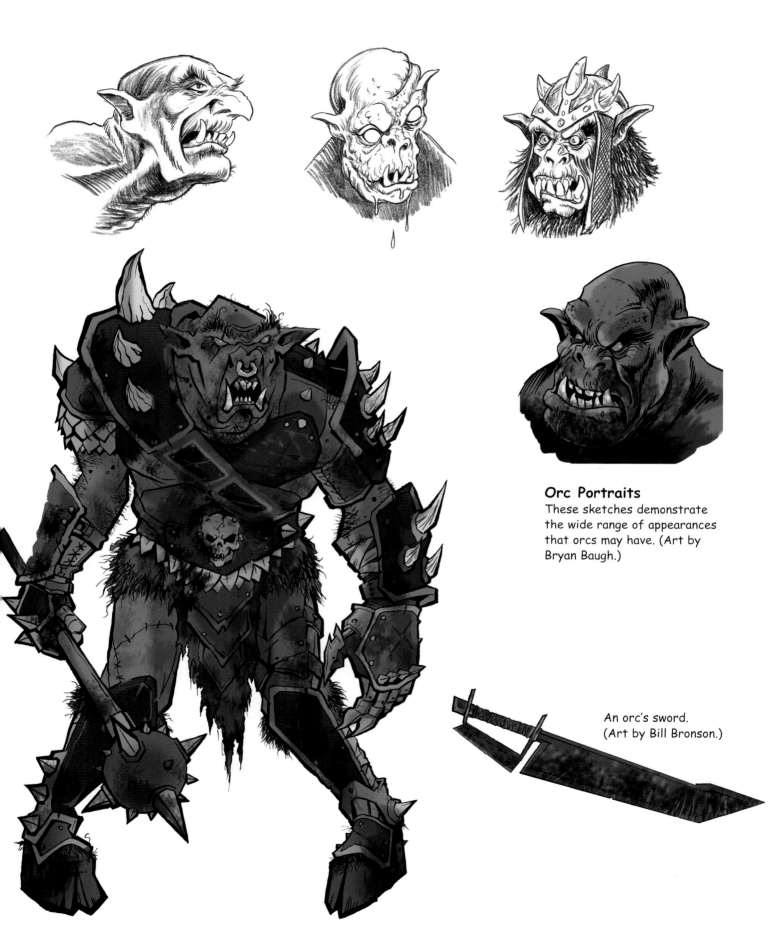

Orc Portraits
These sketches demonstrate the wide range of appearances that orcs may have. (Art by Bryan Baugh.)

An orc's sword. (Art by Bill Bronson.)

ORC CAPTAIN

The orc captain is a fierce leader of the orc army. There is a lot of ugly attitude in this character, and it's all in his pose. If he were slouching forward, he would look like just another orc soldier. But the orc captain stands tall and proud. His back is arched, his chest is thrust out defiantly, and his feet are planted far apart, giving him a solid stance. His armor is an elaborate series of plates and sharp spikes. The armor can be constructed out of simple squares, rectangles, and triangles; the step drawings reveal how to decipher the arrangement of these shapes.

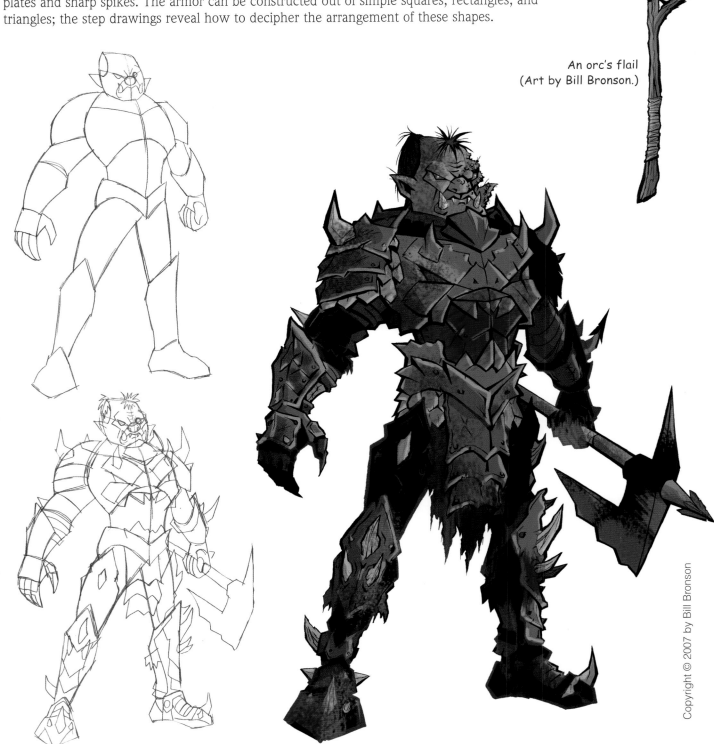

An orc's flail
(Art by Bill Bronson.)

OBESE ORC

Like human beings, orcs come in a variety of shapes and sizes. It's always fun to play with
different body types when creating fantasy characters. So here is a monstrously obese orc.
Note that the basic shapes used to construct his overall form are totally different from those
used in drawing a standard orc. Yet he remains vicious and scary looking.

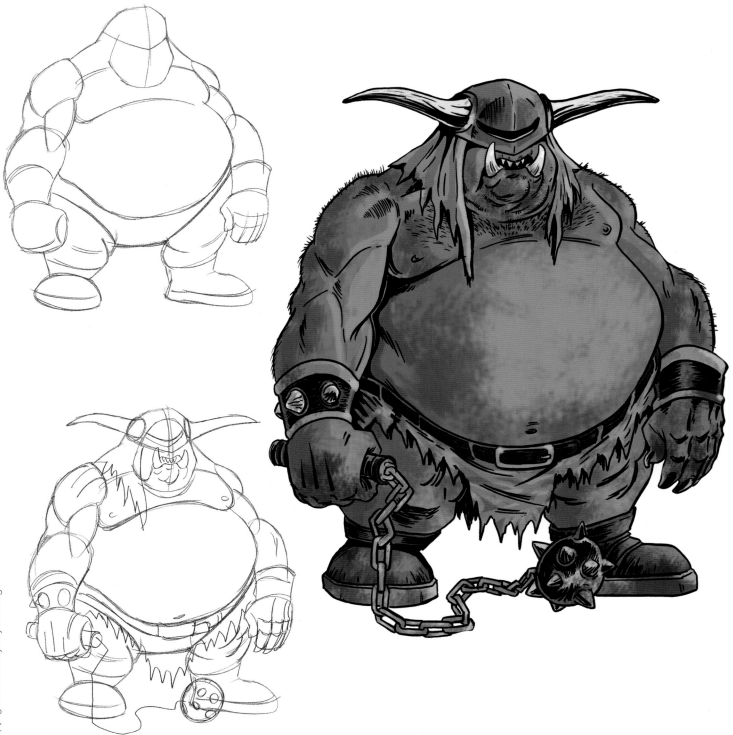

TROLL

Trolls are giant-sized relatives of orcs and goblins, but they're not quite as smart as either. They are incredibly strong, incredibly mean-tempered, and incredibly simple-minded. Because they love to maim and smash things, and because they are so easily excited by the frenzy of war, trolls are often used by orcs as big, dumb, enthusiastic powerhouses who can be sent barreling into a battle to frighten and overwhelm an enemy.

There are many different breeds of trolls, and they can look very different from one another. This particular specimen is an especially nasty brute. As you draw him, pay close attention to the relative sizes of the various parts of his body. Note that his head is disproportionately large. This helps to make him look oafish and dim-witted.

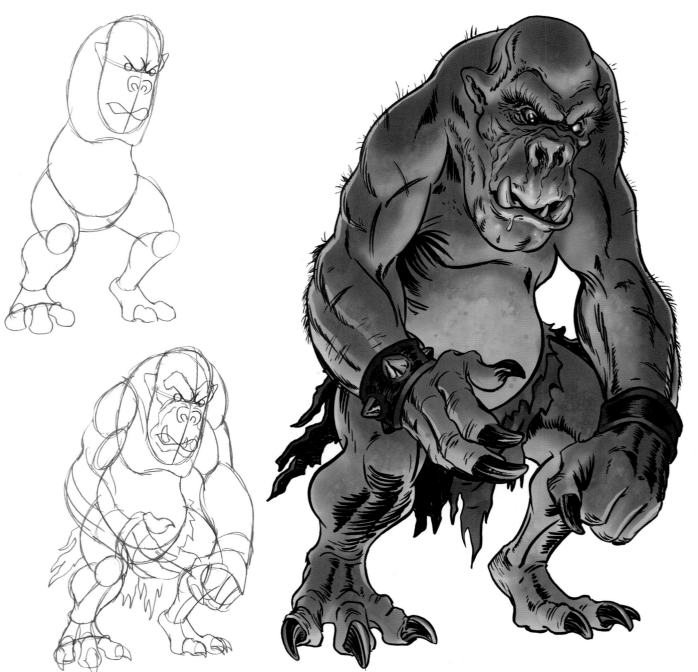

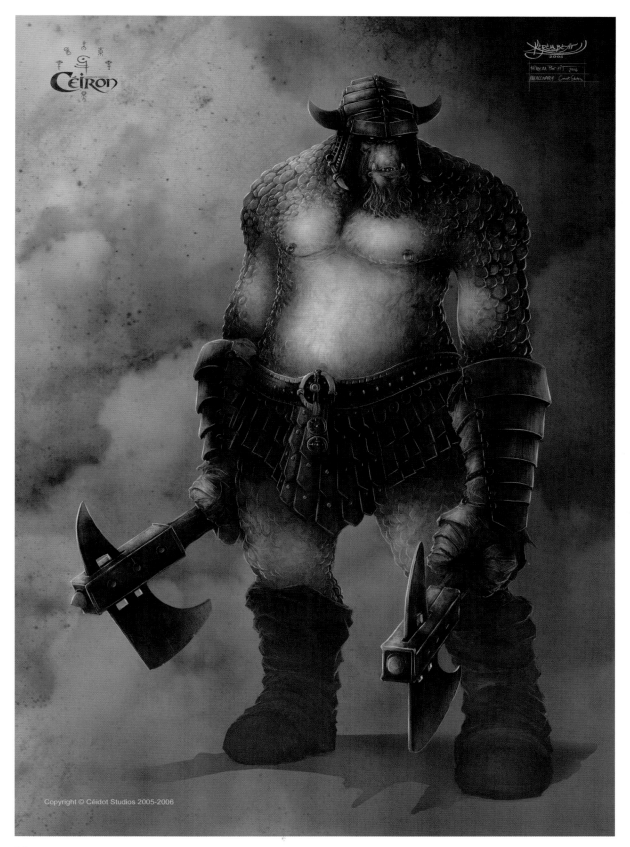

Mercenary
Evil kings, sorcerers, and orcs often employ slow-witted trolls to do their dirty work for them. (Art by Kerem Beyit.)

WARRIOR TROLL

The physical appearance of trolls can vary widely. The proportions of this warrior troll, wearing battle armor and wielding a sword, are quite different from those of the troll on the previous pages. Instead of a giant head, we've given this guy giant hands and giant feet. It's a subtle change, but it gives a very similar type of character a very different overall look and personality. This is an example of one simple trick you can experiment with when designing your own fantasy characters.

Battle Axe

A well-armed troll stands atop the bodies of his victims in this appalling battlefield scene. (Art by Adam Vehige.)

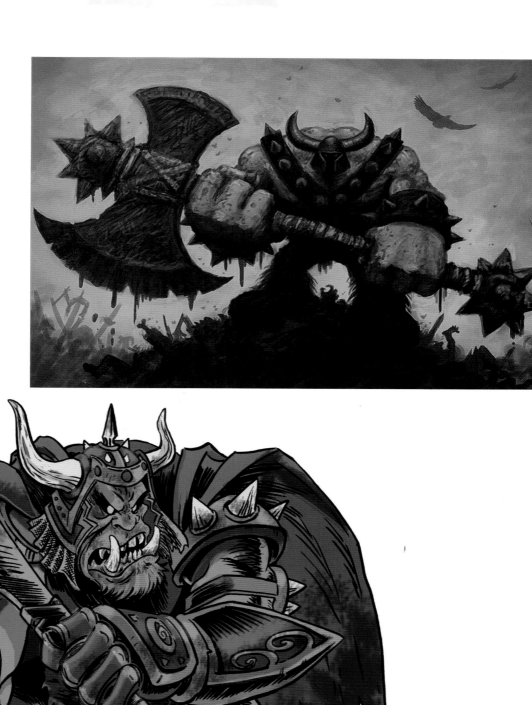

Ogre

Large, savage, and carnivorous, ogres are monstrous primates who lurk in forests, caves, and abandoned dungeons. They have a certain brutish intelligence—just slightly above that of apes. They will attack humans without being provoked (and will eat them if possible). Drawing this character is an exercise in distorted human anatomy. Notice that his figure is similar to that of a man, but taller, and longer in the limbs and abdomen. His hands and feet are far larger than a normal human character's, and his head, obviously, is not at all human-like.

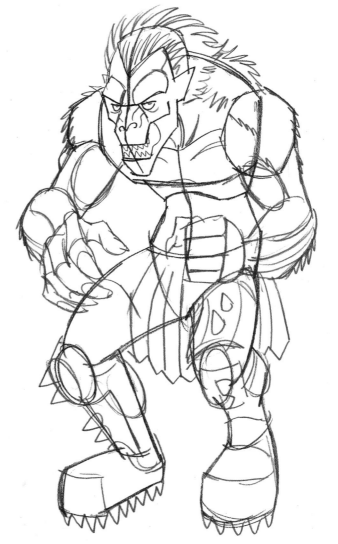

Portrait of an Ogre
This specimen belongs to an unusual breed of horned ogres. (Art by Bryan Baugh.)

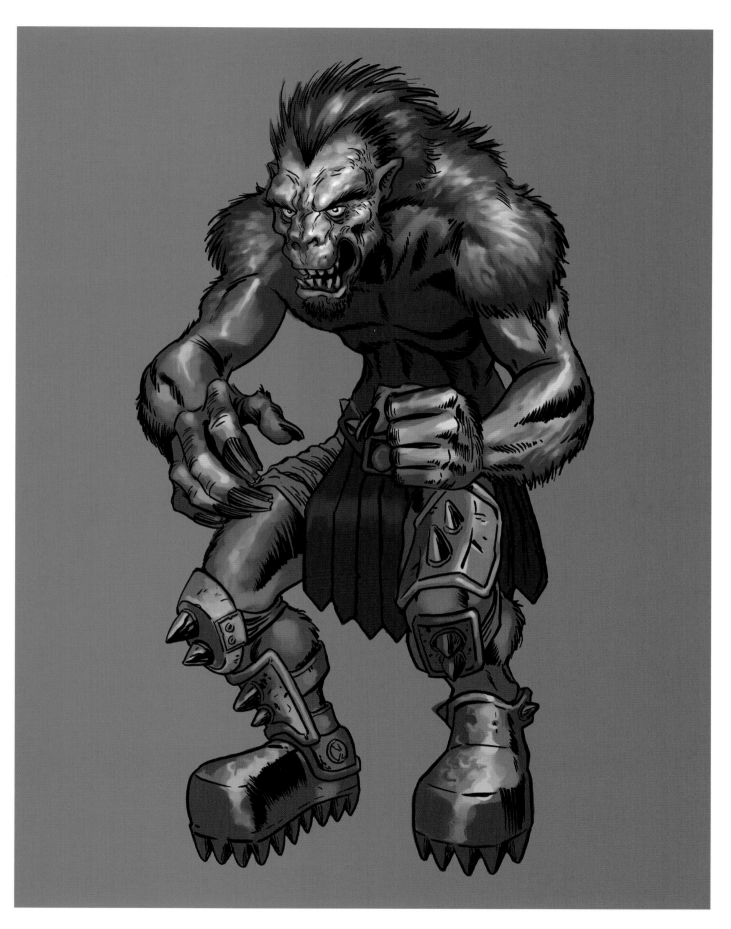

GIANT

There are many races of giants. The one depicted here belongs to a breed that dwells in forested, upland environments. Because these towering beings hide amid the trees and mist of vast mountain ranges, it is a rare occurrence to come across one. And because giants display a wide range of personalities and dispositions, such an encounter might have a wide range of outcomes. There are giants who will help lost travelers find their way home, and then there are giants who will happily grab travelers and spend the rest of the day nibbling the flesh from their bones. Because giants are proportioned more or less like human beings, drawing them is basically the same as drawing an imposing human character. To help make your giant look gigantic, you can show him standing next to an immediately recognizable object, whose scale—in relation to the giant—indicates just how big he really is. Try putting him next to a tree that comes up only to his shoulder—or to a human being who comes up only to the giant's ankle!

OTHER RACES OF GIANTS

Each variety of giant seems to have its own preferred environment. Lava giants live inside volcanoes—emerging with a great eruption of red-hot lava. Storm giants are denizens of the deep seas. Frost giants—who live in frozen, polar regions—are perhaps one of the more common breeds. Typically, they dwell in ice caves carved from glaciers. More intelligent than the other breeds of giants, they are more inventive in weapon making and cleverer in battle. As with the forest-dwelling giant, drawing this frost giant isn't much different from drawing an ordinary human male. He is proportioned the same as an ordinary human. But you can make him appear large by the objects and scenery you place around him.

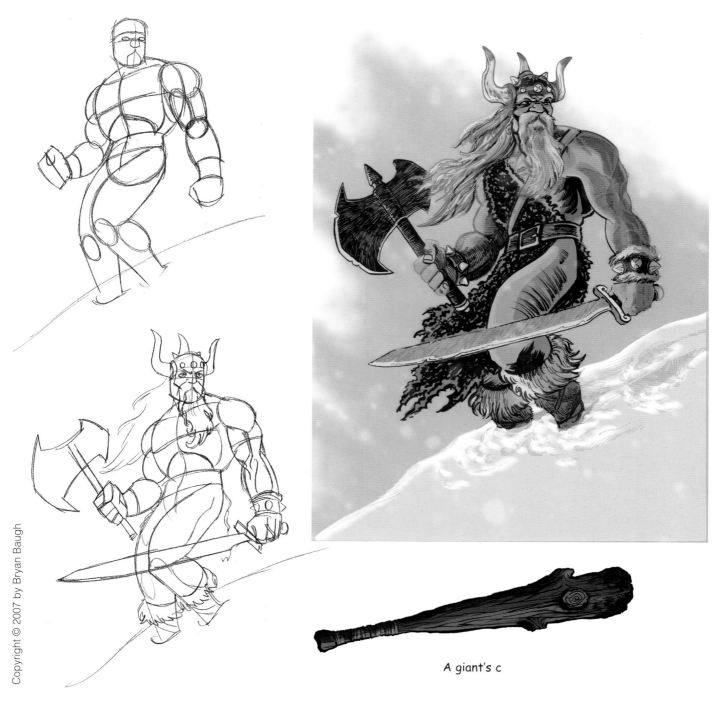

A giant's c

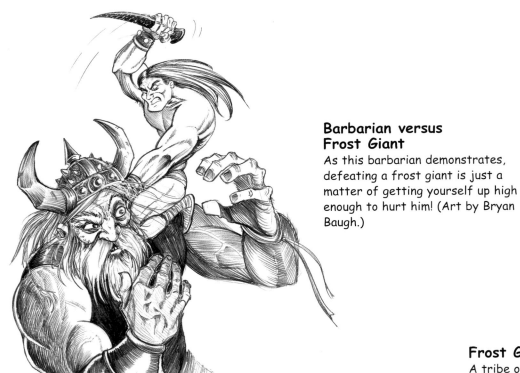

Barbarian versus Frost Giant

As this barbarian demonstrates, defeating a frost giant is just a matter of getting yourself up high enough to hurt him! (Art by Bryan Baugh.)

Frost Giants Attack

A tribe of frost giants bursts up through the ice, making a deadly surprise attack on a human village. (Art by Jeff Fairbourn.)

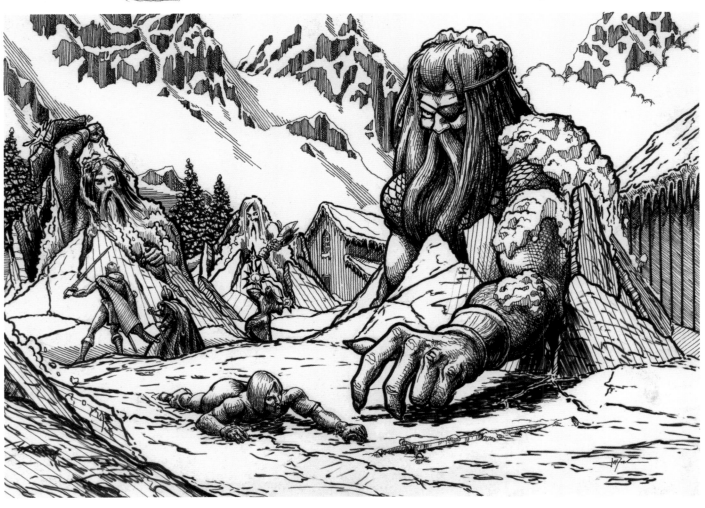

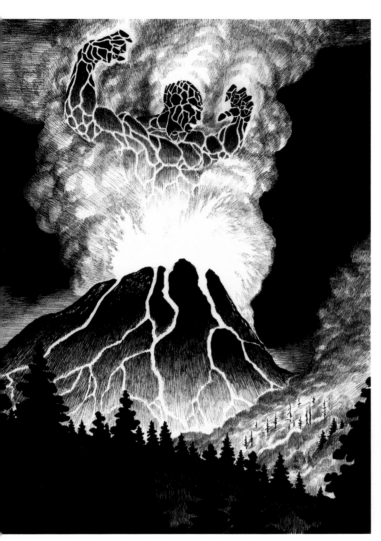

Lava Giant
Lava giants are among the rarest breeds. Here, a lava giant rises up from a volcano. (Art by Jeff Fairbourn.)

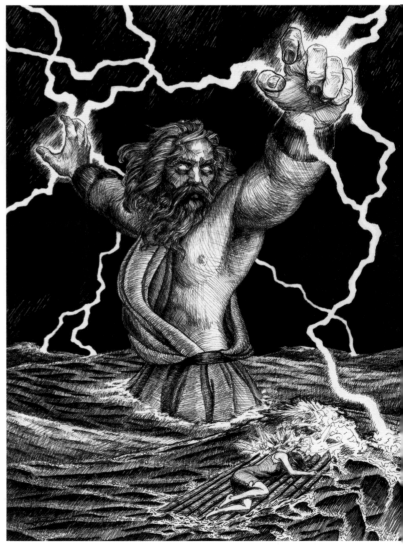

Storm Giant
This giant lives in the sea, and he's powerful enough to control ocean storms. (Art by Jeff Fairbourne.)

CYCLOPS

Closely related to trolls, distant cousins of the giants, the cyclops is an enormous humanoid creature whose distinctive physical characteristic is his single eye. There are different breeds of cyclopes, with a variety of appearances—some sophisticated, others savage and animalistic. The cyclops presented here is of a monstrous sort, with ape-like body proportions. His semi-human head is constructed using a small round shape for the upper half and a wide, blocky shape for the lower half. His shoulders are broad and massive, his arms thickly muscled. His stomach is a potbelly, and his arms are much longer than his legs. Giving him this gorilla-like frame adds to the impression that he is a very savage primate.

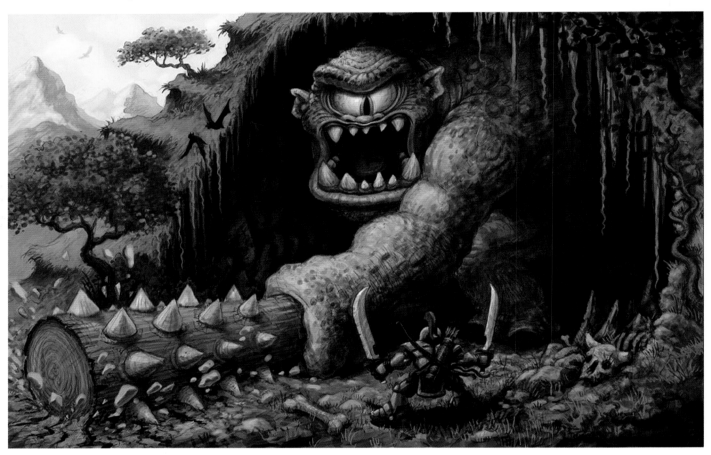

Cyclops Attack
As an angry cyclops, wielding a spiked club, emerges from his lair, the hero—equipped with two swords—appears ready for the confrontation. But who knows what the battle's outcome will be? (Art by Adam Vehige.)

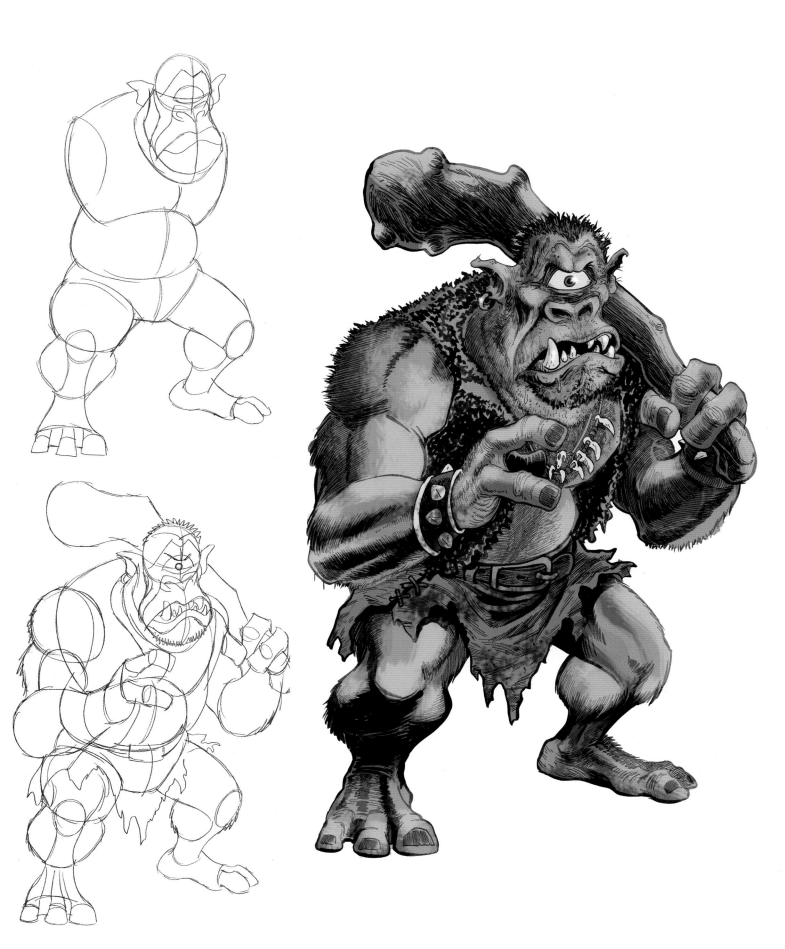

PART TWO
CREATURES OF THE FANTASY REALM

OF ALL FANTASY CHARACTERS, IT'S THE NONHUMAN creatures that allow the artist to enjoy the most freedom to indulge his imagination, to bend the rules of figure drawing, and to have fun constructing totally bizarre anatomical forms. Simply put—this is where you get to make monsters!

In the following chapters we'll take a look at a variety of strange beings and wildlife—from the magical to the malevolent, from the graceful to the grotesque, from the intelligent to the savage, and from the part-human to the totally nonhuman. These creatures are derived from fairy tales, mythology, and ancient legends, and all of them have become icons of the fantasy genre. Drawing them is simply a matter of learning how to take the same basic shapes you've used to build your humanoid characters, alter them slightly, and assemble them in different ways.

Earth Dragon
This fire-breathing dragon—shown in closeup—is truly terrifying. (Art by Daniel Lundquist.)

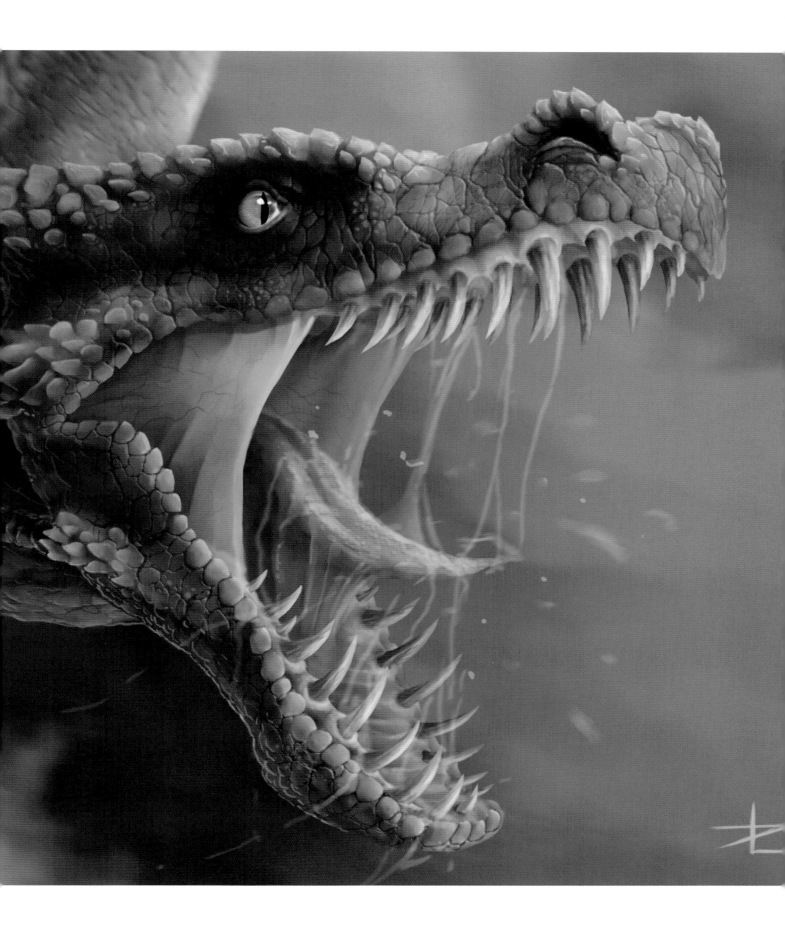

Half-Human, Half-Animal Beings

CREATURES THAT ARE PART HUMAN AND PART ANIMAL appear in many legends. After all, what could more interesting than the idea of an almost-person who possesses the physical prowess of an animal? Some of these creatures are helpful to humans, others harmful. Some are intelligent, some only quasi-intelligent. Some are good, some are evil. And some are friendly while others are quite dangerous. But all require an understanding of the human figure as well as a grasp of animal anatomy for you to create them on paper. These characters are for the advanced fantasy artist, and you will find that many of them are harder to draw than they look. But remember, in the old Greek myth, Theseus overcame the Minotaur through careful planning. If you follow the steps and instructions given, perhaps you will, too!

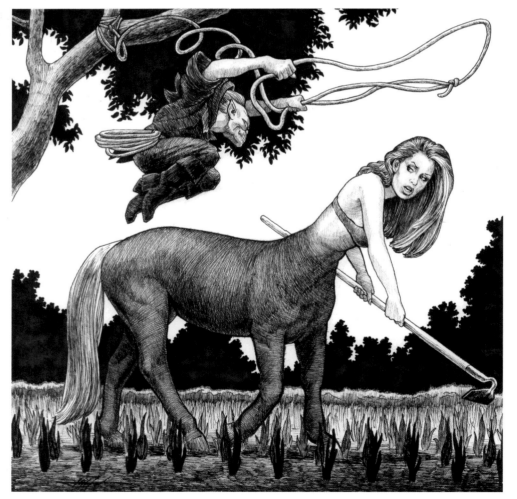

Centaur Roundup
A goblin attempts to lasso a female centaur. (Art by Jeff Fairbourn.)

BOAR GIANT

An enormous race of humanoid boars, the boar giants are savage creatures that live in caves, woods, and other shadowy places. They are generally reclusive, but if disturbed they become fierce, unrelenting attackers. Their dwellings are always foul smelling and littered with the bones of the many animals they've feasted on. Little is known or understood about their social behavior, but they tend to live in groups, with one very large male acting as the protector of the herd. Drawing this character will present a challenge similar to that of drawing an ogre or troll. Here, you have a basically humanoid body with an animalistic head, hands, and legs.

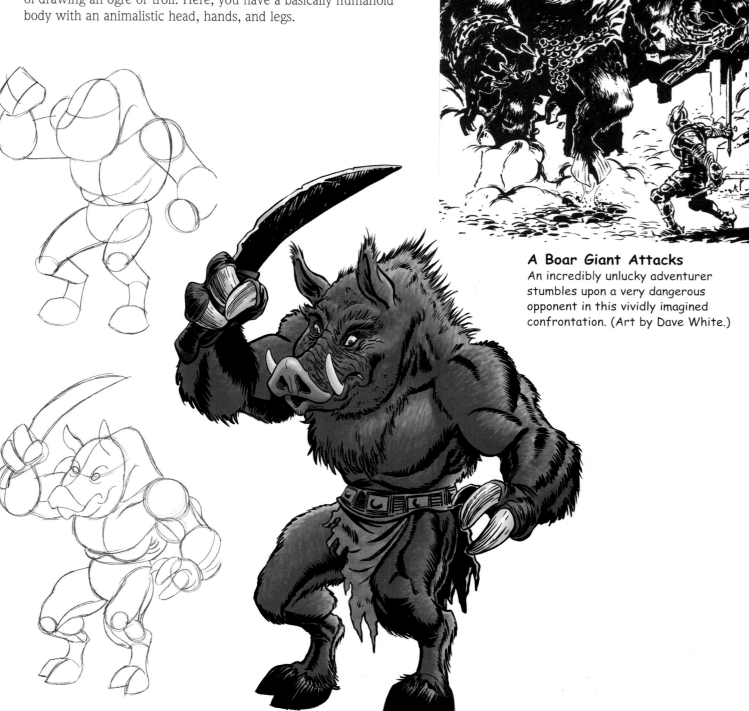

A Boar Giant Attacks
An incredibly unlucky adventurer stumbles upon a very dangerous opponent in this vividly imagined confrontation. (Art by Dave White.)

Centaur

An intelligent race of creatures whose upper body is that of a human being and whose lower body—from the waist down—is that of a horse, centaurs may be good or evil. In some legends, centaurs are noble companions and fierce protectors of human beings. They fight alongside humans in battle and guard them against evil creatures. Centaurs can even sense sadness in people and will show up to comfort and advise them. This warm, protective depiction of the centaur is, naturally, the most popular one. But there are other stories, too—stories in which centaurs are violent, raging monsters, who feel a nasty rivalry with, and an unforgiving hatred toward, men.

To draw the centaur, you have to be able to handle human anatomy (from the waist up, anyway) as well as horse anatomy (from the horse's shoulders down, that is). Then you've got to be able to adorn the whole character in battle armor—another challenge. It's an exercise requiring care, so follow the steps shown to get an understanding of the basic shapes that make up this character's complex form. If you can figure out those basic shapes, you will have learned to draw one of the most difficult characters in this entire book.

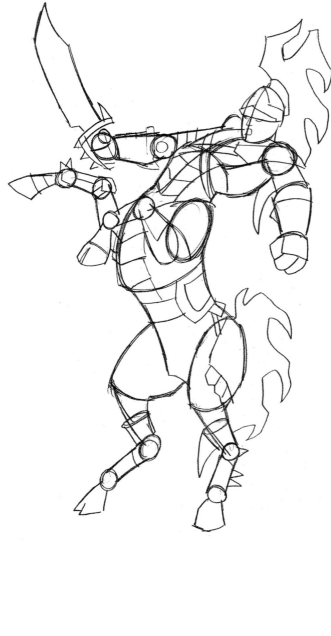

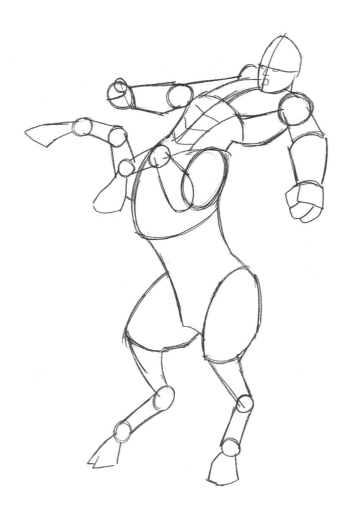

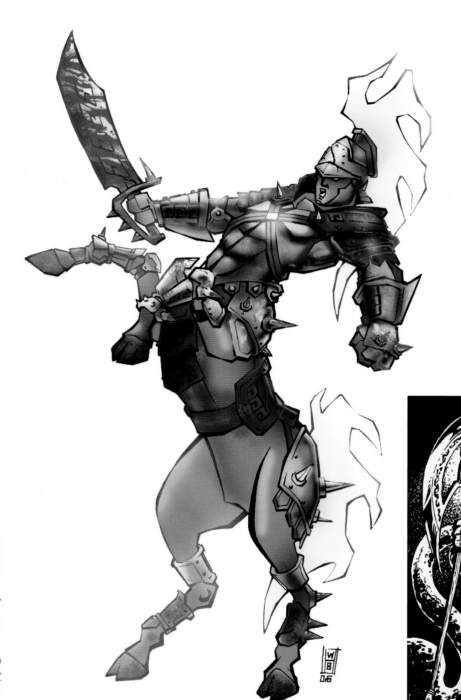

Centaur versus Snake

Able to wield formidable weapons and trample with powerful hooves, a centaur has no trouble holding his own against a giant serpent. (Art by Dave White.)

Mermaid

Beautiful and mysterious, mermaids live in vast cities at the bottom of the ocean and are occasionally witnessed by sailors and pirates at sail on the high seas. Good creatures by nature, mermaids are known to rescue drowning people and carry them back to shore. But they can also be quite mischievous. According to some legends, on very rare occasions—and very briefly—the tails of mermaids will turn into human legs, allowing them to go ashore and walk on land. (Some legends claim that this can only happen one day per year; others say it can happen only once in a mermaid's entire life.) As a result, there are many stories about men who meet a beautiful girl on the beach and fall in love with her, only to be heartbroken when she dives back into the water and swims away laughing, never to be seen again.

Drawing the mermaid is simpler than it looks. Her upper body is, after all, that of a normal human female, with a few added features, such as the fin on her back. Her lower half gets progressively narrower as it tapers down to its fishtail-like fins.

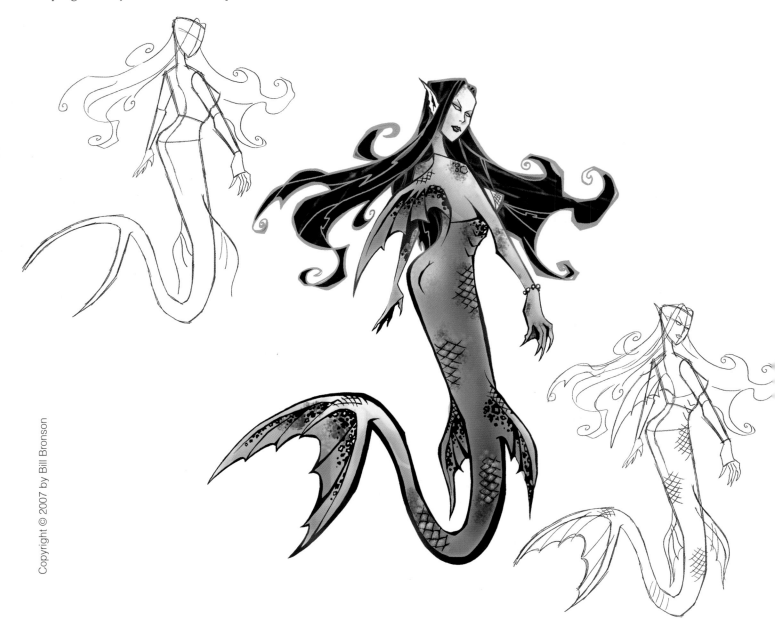

Lizard Soldier

These intelligent reptiles walk upright like humans and are at least as smart as orcs. They can have a wide range of temperaments, from downright mean to deadly. With their powerful bite, razor-sharp claws, lashing muscular tails, and ability to fight with hand-held weapons, you can imagine what fierce adversaries they make in any sort of combat situation.

Construct this lizard man the same way you would an ordinary human character, but note that the lizard man's anatomy is humanoid only from his shoulders to his waist. His head, obviously, is that of a lizard, but his legs are equally inhuman. They are jointed like the hind legs of a real lizard.

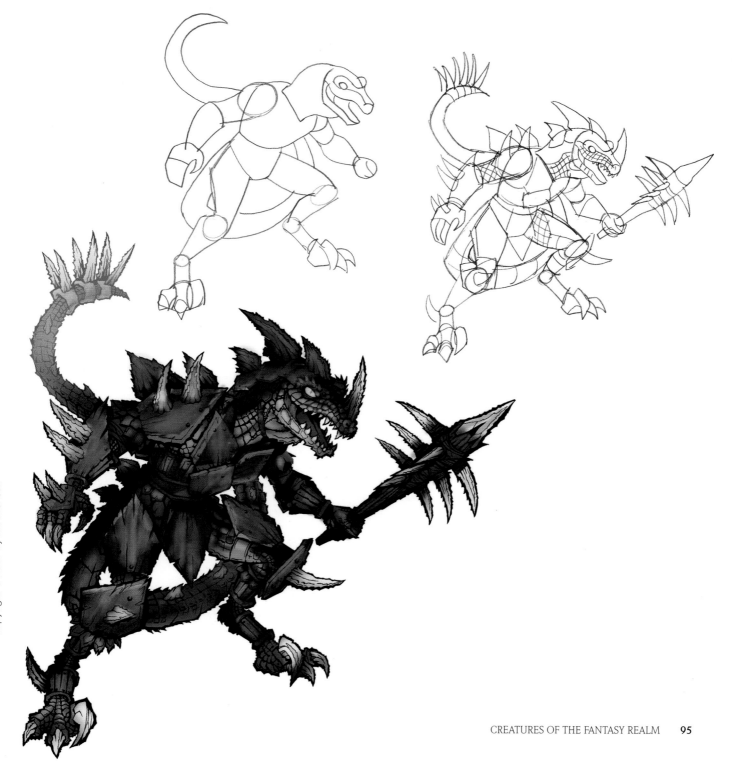

MINOTAUR

Terrifying creatures with bulls' heads and men's bodies, minotaurs live in great stone fortresses whose twisting, turning, intersecting corridors form giant mazes. Unlike ordinary bulls, minotaurs are carnivorous and will emerge from their labyrinthine lairs to snatch human beings and livestock, dragging their prey back into the depths of their mazes before consuming it. The mazes of minotaurs can stretch on and on for miles. Many are located underground, making their extent even harder to determine. But in all cases, minotaur mazes are incredibly complex, and once someone is taken inside, they almost never find their way out. Heroes who venture into such mazes to slay the minotaur and rescue its victims usually end up hopelessly lost in the shadowy, confusing maze until they either starve to death or are found and killed by the minotaur.

Drawing a minotaur is not terribly different from drawing a human character. Both have the same basic body structure. The head and legs are those of a bull, however. These parts may look challenging, but they can be constructed out of simple shapes. After laying down these basic shapes, you can give the hide a furlike texture by going over their outlines with a series of short, "hairy" lines.

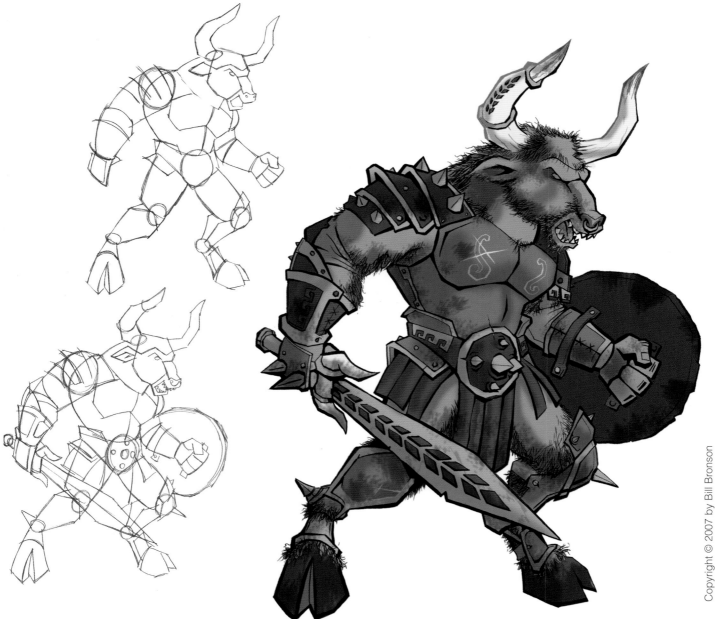

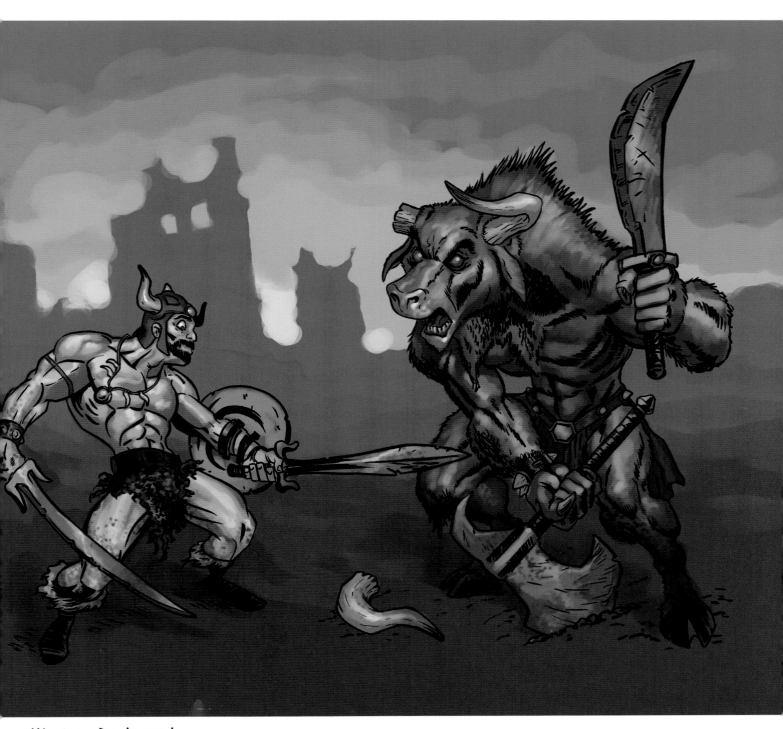

Minotaur De-horned

This warrior's first sword stroke didn't do much damage, but it sure made his opponent angry. (Art by Bryan Baugh, colors by Zach Hall.)

Mythological Wildlife

AS WITH HUMAN CHARACTERS, nonhuman creatures can be good or evil. At one end of the spectrum are those who live harmoniously alongside man and may even serve as his allies in times of trouble. The elegant, highly intelligent unicorns, for example, may appear to be harmless, even delicate, but they are aligned on the side of good and will fight ferociously for it. Griffins, too, will come to man's aid . . . if they are in the right mood.

But at the opposite end of the spectrum are the evil creatures, the ones who see human beings only as prey—or as bothersome pests to be slaughtered. Some of these creatures possess enough intelligence, demented though it is, to organize themselves into horrible, monstrous armies, bent on destroying men in order to rule the world themselves.

Still, most fantasy creatures are simply dangerous beasts of animal-level intelligence. Certainly, the aquatic Kraken has no planned agenda, but the monster is nevertheless hostile toward human beings.

Creatures come in many different shapes and sizes, but if you follow the steps given you can see how they each break down, structurally, into simple shapes. These simple shapes should present you with no great challenge or problem. Once you have them down, it simply becomes a matter of assembling them in the correct way. As with all characters, understanding the basic structure is the key to drawing these bizarre creatures correctly.

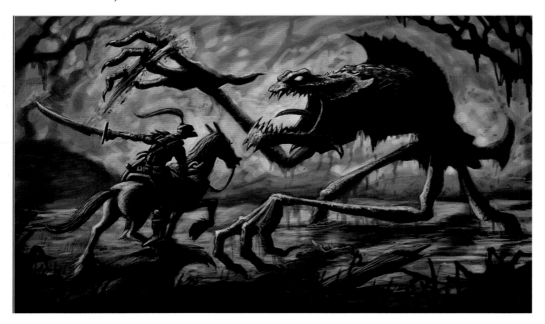

◄ **Knight versus Swampy**
A knight charges into battle against a very strange creature in this miasmal scene. (Art by Adam Vehige.)

▶ **Black Dragon**
Perched atop a jagged cliff, a glowering dragon prepares to unleash its fiery breath. (Art by Daniel Lunquist.)

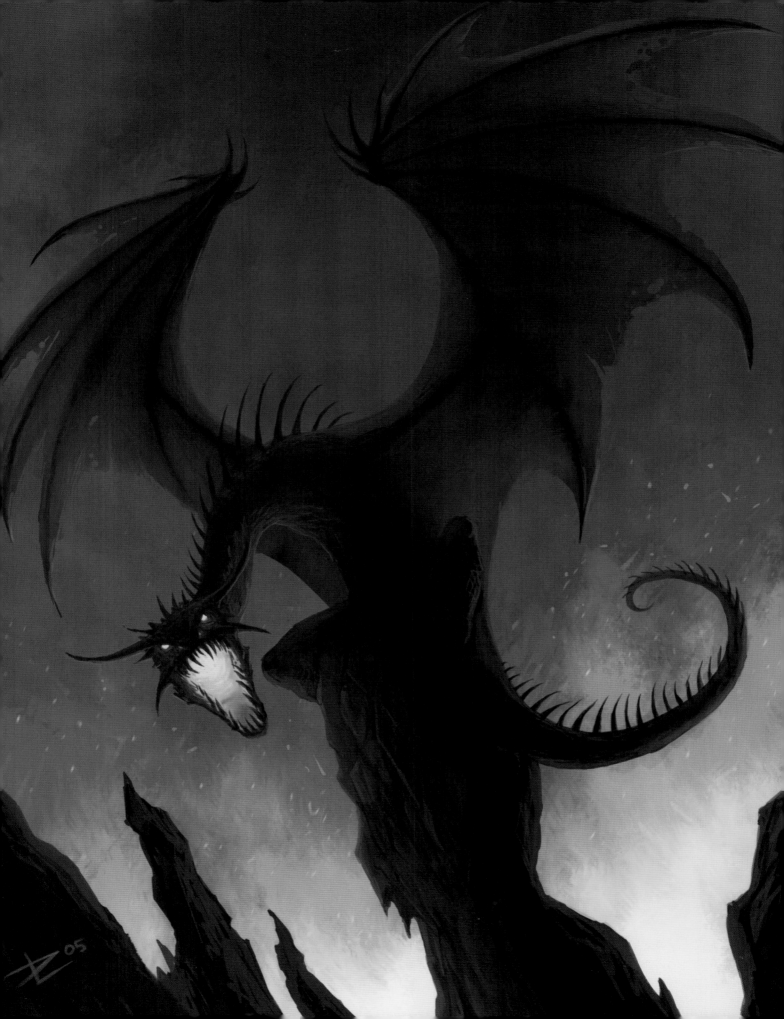

UNICORN

Powerful, mystical, and purely innocent creatures, unicorns are an ultimate symbol of the forces of good. Although they may look like simple, gentle, horned horses, unicorns possess the animal equivalent of genius-level intelligence and have a seemingly magical knowledge of all things happening around them. This, along with their incredible speed and strength, makes them almost impossible to catch or kill.

The proper name of the unicorn's single horn is an *alicorn,* and it is supposedly filled with powerful magic dust that can heal any wound or cure any ailment. For this reason, attempts are made to capture unicorns, but such attempts usually end in failure and death for the would-be trappers. According to legend, unicorns are naturally drawn to sources of purity and can be lured only by children, especially innocent girls.

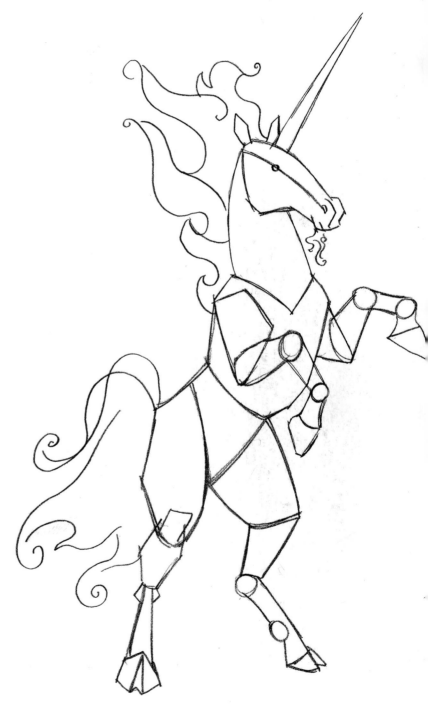

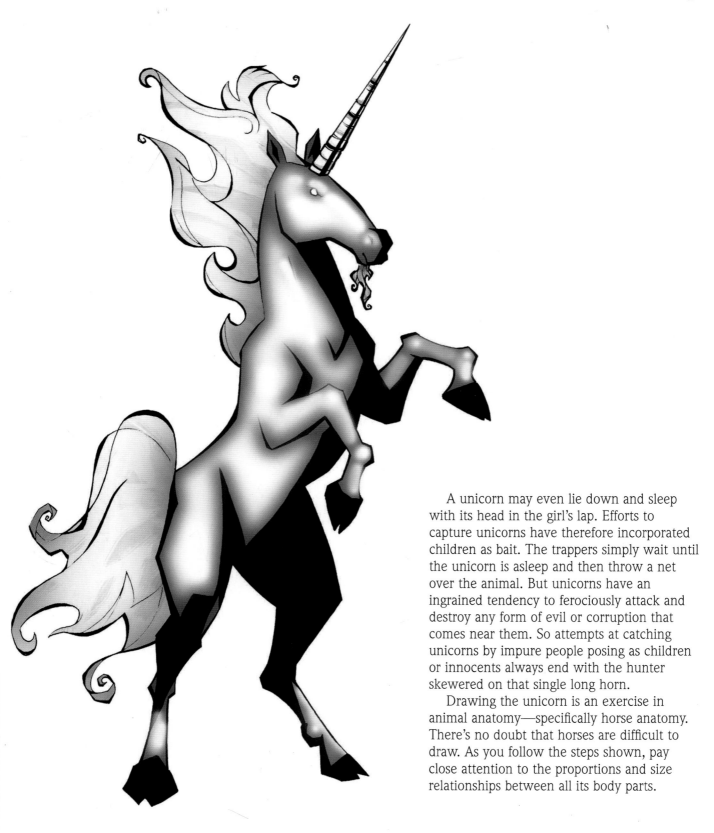

A unicorn may even lie down and sleep with its head in the girl's lap. Efforts to capture unicorns have therefore incorporated children as bait. The trappers simply wait until the unicorn is asleep and then throw a net over the animal. But unicorns have an ingrained tendency to ferociously attack and destroy any form of evil or corruption that comes near them. So attempts at catching unicorns by impure people posing as children or innocents always end with the hunter skewered on that single long horn.

Drawing the unicorn is an exercise in animal anatomy—specifically horse anatomy. There's no doubt that horses are difficult to draw. As you follow the steps shown, pay close attention to the proportions and size relationships between all its body parts.

GRIFFIN

Living symbols of strength, griffins are intelligent flying creatures that have the head and wings of an eagle combined with the body—and the power—of a lion. They are friendly and protective toward good humans. During times of war, griffins are known to appear in kingdoms ruled by good kings, especially if those kingdoms are being threatened by a truly evil enemy. Griffins guard castles and temples and will accompany men into battle. When fighting for good, griffins are devastating. Incredibly fast, agile, and strong, they are equally well-equipped for combat on the ground and in the air.

As with the centaur, the challenge of drawing a griffin is knowing how to draw two different types of creatures (in this case, an eagle and a lion) and then combining parts of those creatures into a unique animal. This can be tricky, because it means you have to make something very unnatural look natural.

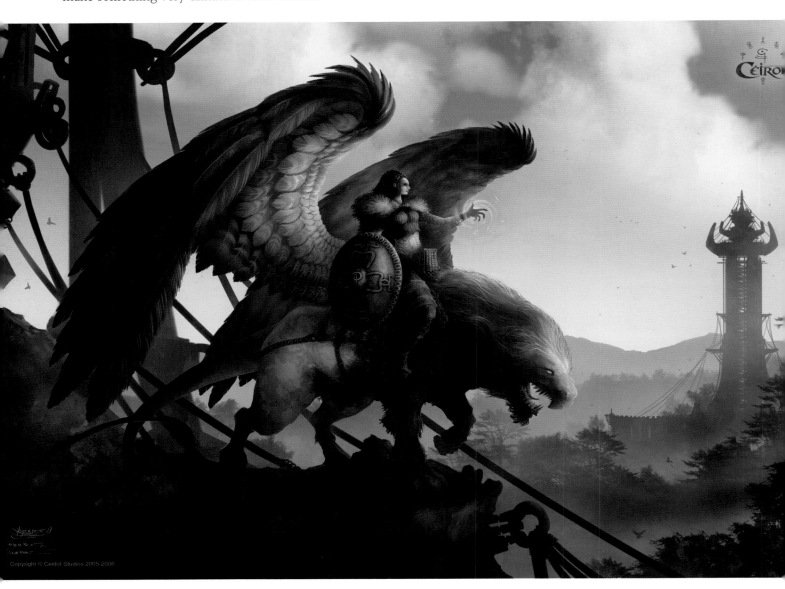

Galonian Atronist
A temple is well guarded by a bold warrior astride a griffin steed in this evocative landscape. (Art by Kerem Beyit.)

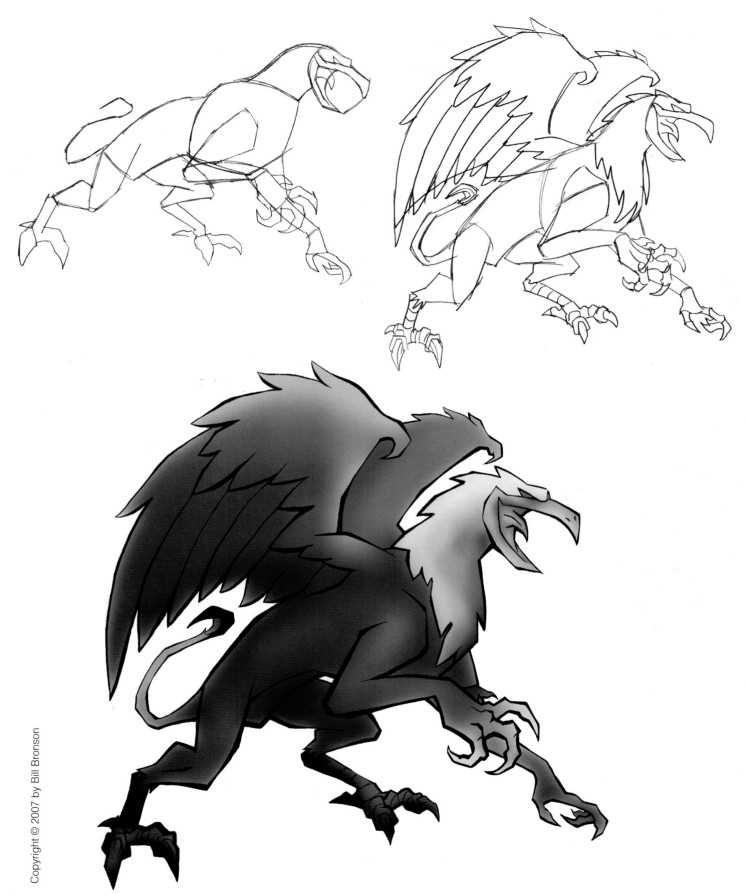

ROC

Rocs are gigantic birds known to swoop down and snatch away lone human beings. People who get nabbed by a roc are usually carried into the sky and dropped into the roc's nest, to be devoured by giant hatchlings. These monstrous, aggressive birds tend to live near water, roosting in beachside caves or atop mountains along island coasts. Unlike most animals, rocs do not mind human beings straying into their territory; after all, that just means more food for their babies.

Needless to say, drawing the roc, unlike drawing most of the other monsters in this book, is a total departure from human anatomy, for this creature is all animal. The rules are totally different, but the approach is the same as that you would use when drawing a human character. The big bird's spine gives you the thrust or posture of the character's body; simple shapes can be used to nail down the basic forms of the head, body, and legs. The most challenging part is the wings, but even these become simple if you look past the detail to see the simple shapes with which they are constructed.

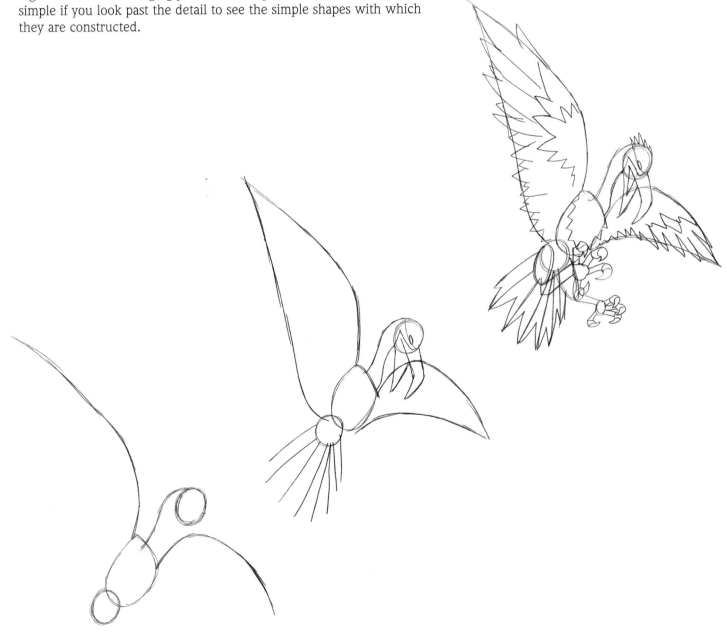

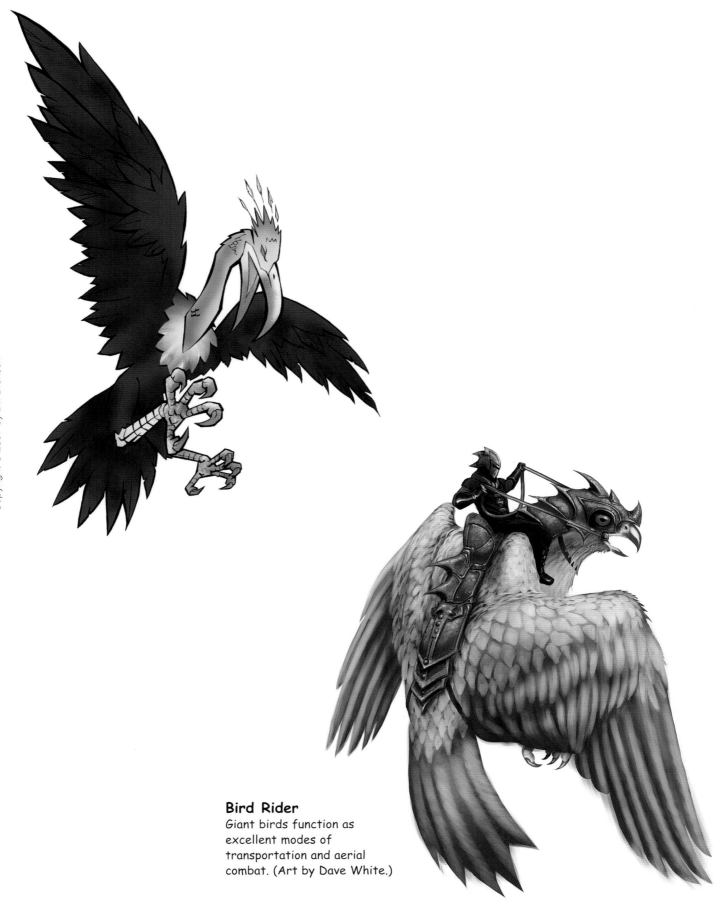

Bird Rider
Giant birds function as excellent modes of transportation and aerial combat. (Art by Dave White.)

KRAKEN

The Kraken is a gargantuan aquatic monster that lives in the depths of the ocean. Different legends describe it in different ways. According to some stories, the Kraken is simply a giant octopus or squid. In others, it appears as a giant demon-fish, and in yet others it appears as an enormous, scaly, green, humanoid monster. For our purposes, we have combined all these descriptions into one monster. Note his fishlike face, demonic horns, and tentacled arms with finned hands. This creature will be fun to draw for those who enjoy making up totally new imaginary forms. By learning the basic shapes of our Kraken's construction, you can draw a Kraken like ours. Or you can combine fish, humanoid, and monster parts in your own way to create your own version of the legendary monster.

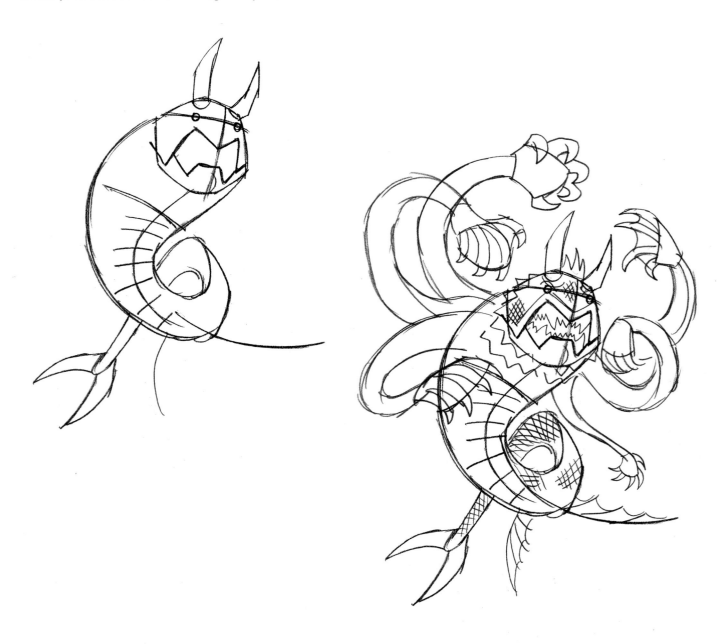

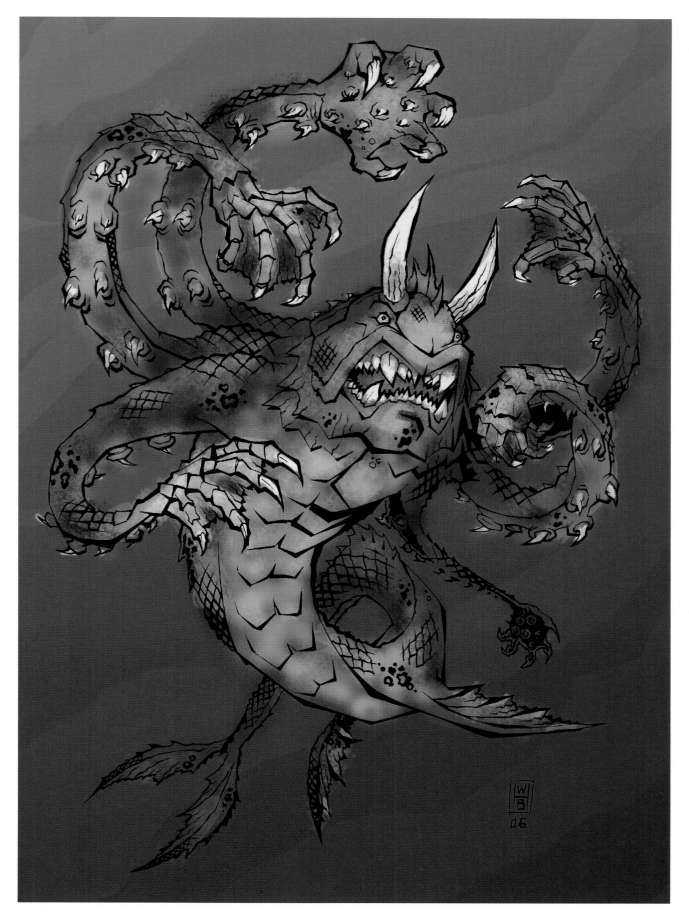

Dragons

IT GOES WITHOUT SAYING that dragons are among the classic icons of fantasy fiction and art. Of all the fantastic characters and creatures that populate the sword-and-sorcery genre, dragons are the most famous, most beloved, and, arguably, the most interesting. Dragons can come in a variety of shapes and sizes. Some are like giant snakes; others resemble dinosaurs; still others are four-legged monster-lizards. But no matter the specific form, dragons are almost always scaly and reptilian in appearance. They usually have horns, crocodilian snouts, sharp teeth, forked tongues, and forked tails. And they're usually winged creatures, able to fly. Although most people probably think of dragons as green or brown, they can come in a wide range of colors. There are red dragons, blue dragons, and, in some stories, white dragons, who live in snowy regions. In short, there are no hard and fast rules about what dragons must look like, and you should feel encouraged to design your own mythical serpents according to your own personal preferences.

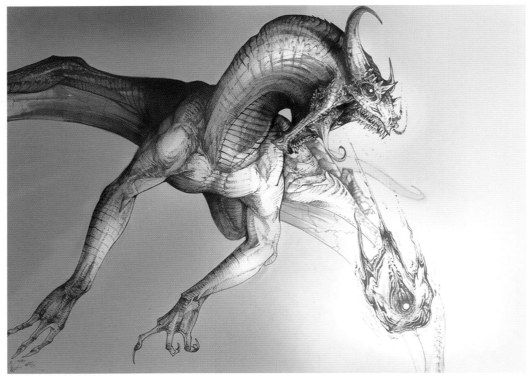

Dragon of the North
A magnificent white dragon strikes a dynamic pose. (Art by Amelia Mammoliti.)

Rocza and Loiosh
A mating pair of male and female dragons enjoys a quiet morning in the forest. (Art by Kerem Beyit.)

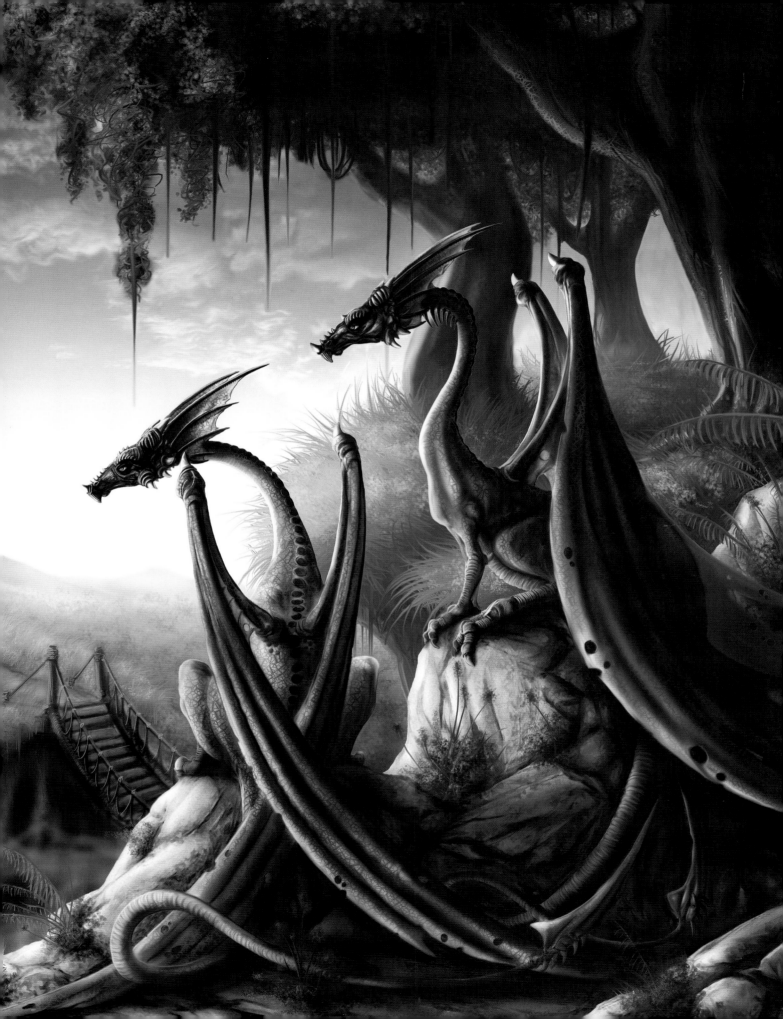

REAL-WORLD DRAGON RESEARCH

Even when working within the world of sword and sorcery, it's always a good idea to punch up the fantasy with a healthy dose of reality. And this is true even when drawing dragons, those most mythical of all fantasy creatures. If you want to bring your dragons down from the clouds of imagination and turn them into living, breathing, flesh-and-blood animals that your viewer can believe in, you've got to imbue them with a bit of naturalistic, real-world grit.

To do so, research real reptiles. There are countless species of snakes and lizards, each with its own unique colors, patterns, and anatomical variations. Find photos of these animals to use as references, and incorporate their best features into your dragons. Crocodiles, alligators, and other, related reptiles (caimans, gharials) display a range of different scale patterns on different parts of their bodies. You may find them inspiring. Even such unlikely (and un-dragon-like) animals as turtles and tortoises, as well as amphibians such as frogs, toads, and salamanders, can offer a wealth of unusual features that could make for interesting dragon details. If your dragon is a winged creature, you will want to examine the wings of bats. You can create some very impressive dragon wings by imitating bat's wings. Look closely at their structure—the way the bones are connected, almost like the finger bones of a human hand. And pay special attention to the various ways that a bat's wings flex and bend.

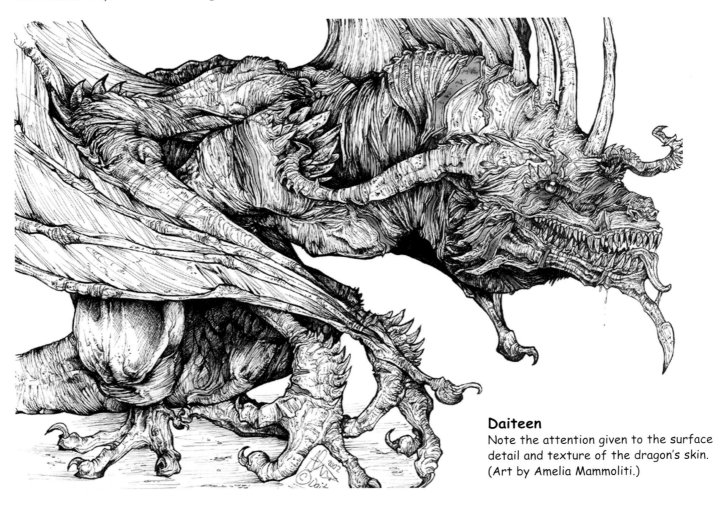

Daiteen
Note the attention given to the surface detail and texture of the dragon's skin. (Art by Amelia Mammoliti.)

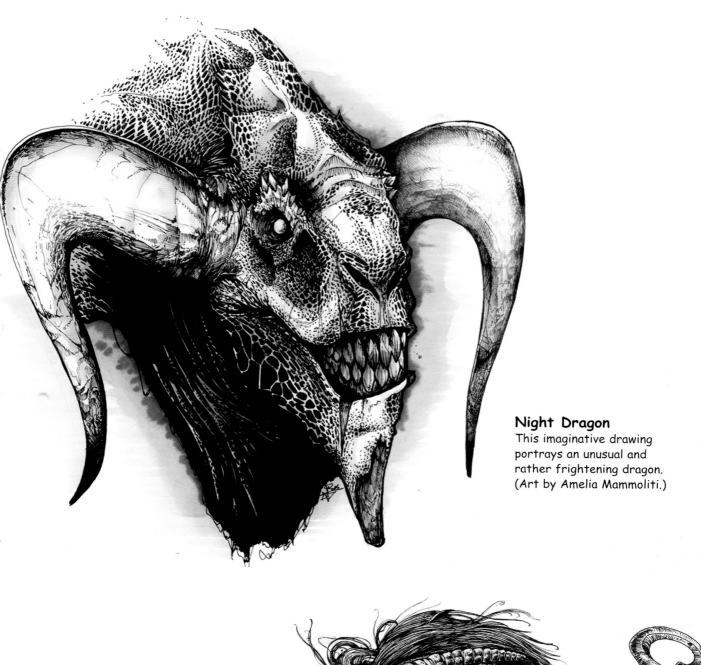

Night Dragon
This imaginative drawing portrays an unusual and rather frightening dragon. (Art by Amelia Mammoliti.)

The Sitter
In this drawing, a winged female dragon tends to her eggs. (Art by Amelia Mammoliti.)

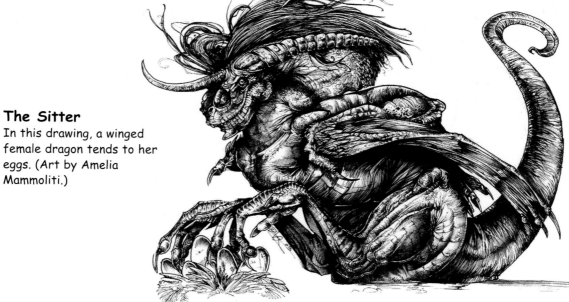

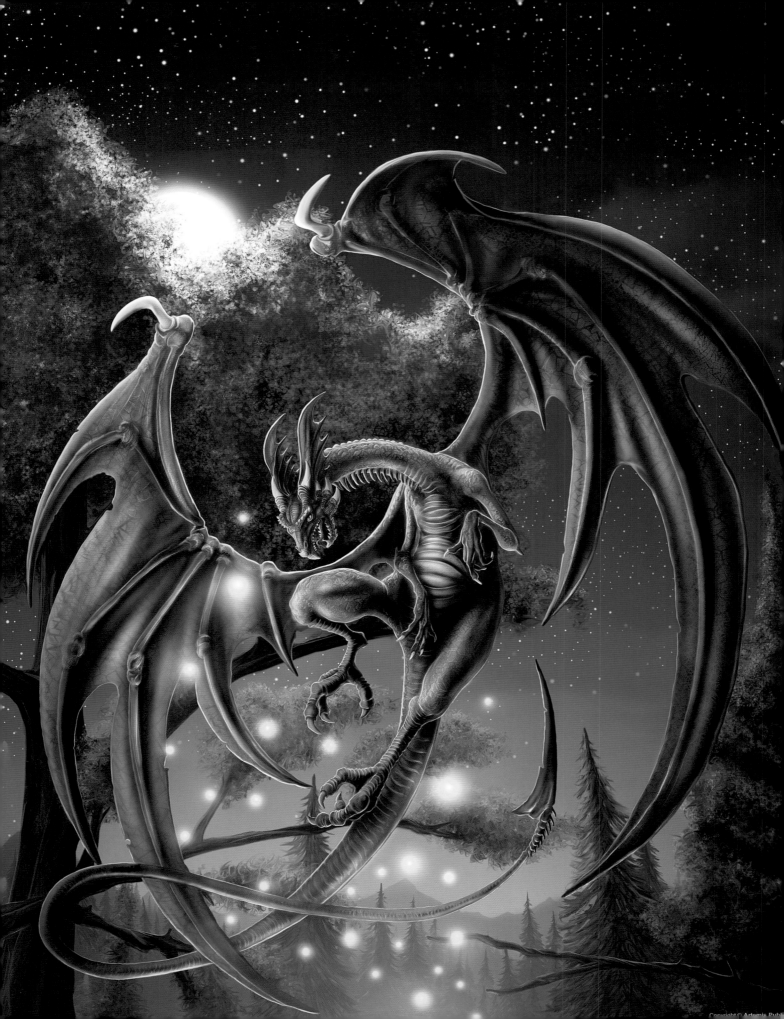

Dragon Personalities

How you design your dragon will be based on the personality of the creature in question. Dragons' personalities can be just as varied as their appearances. The classic dragon, as it appears in most fantasy fiction, is an evil monster that must be slain by the hero. Either it is hoarding some treasure in need of recovery, or it has captured a princess in need of rescue, or it has caused destruction to villages in need of revenge. In such cases, you will want to depict the dragon as a sinister, almost demonic beast, with narrow, slit eyes and rows of sharp, jagged fangs, its body slinking, crouching, or arching in lizard-like poses. Even in repose, the dragon should have a coiled energy, as if it could launch itself into a full-blown attack at any moment. The idea is to make it appear threatening and dangerous. And when such a diabolical dragon is in attack mode, you will want to show its mouth open, its forearms out—displaying those fangs, brandishing those claws. Give its neck an S-shaped curve, to resemble a snake poised to strike.

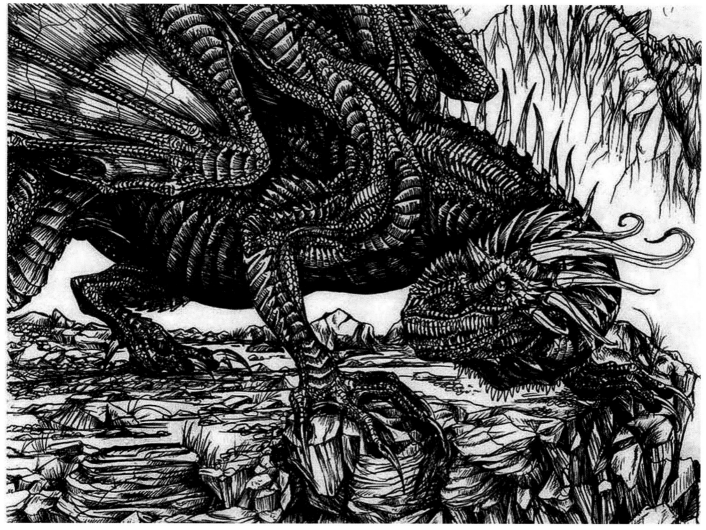

Sly Dragon
A sly pose and exquisite surface detail help bring this dragon to life. (Art by Allison Theus.)

◀ **Jhereg**
This blue-skinned dragon isn't sure what to make of a glowing firefly swarm. (Art by Kerem Beyit.)

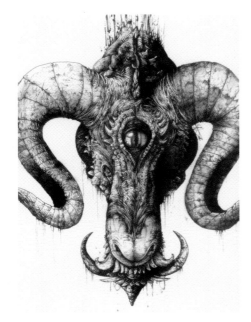

▲ Grimmus Dragon
Stare if you dare into the terrifying, demonic gaze of this ancient, cyclopean dragon. (Art by Amelia Mammoliti.)

▶ Dominant Dragon
A small band of heroes encounters a dragon in its dark, subterranean lair. (Art by Jeff Fairbourn.)

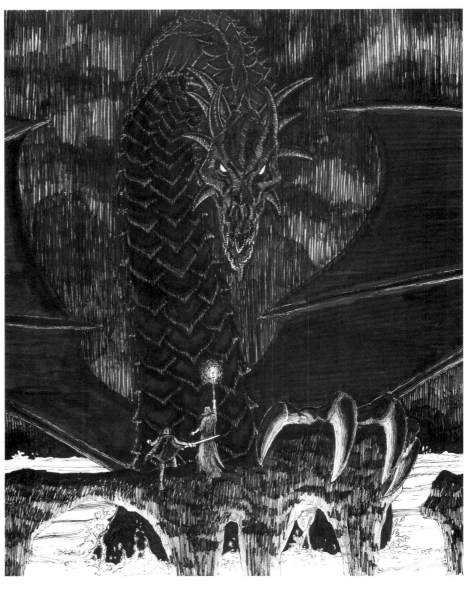

Keep in mind, however, that it is not impossible to depict dragons as good, benevolent creatures—even despite their serpentine appearance and all those teeth, claws, rough scales, horns, and other sharp, pointy edges. In some stories, dragons are intelligent, magical beings that have no interest in hurting others. In Chinese culture, for example, dragons are symbols of good fortune. Likewise, there are many fantasy stories in which dragons are helpful to people, offering wise advice, gifts of magic, or protection from danger. In drawing a benevolent dragon, you'll still want to emphasize its dynamic, monstrous attributes, but simply by giving it a more graceful appearance—and a less threatening pose—you can create a dragon that looks inviting, even friendly, rather than vicious. The secret to making these malevolent-looking monsters appear to be good-natured lies in how you handle their "body language." This might sound strange, but instead of using a snake or lizard as your inspiration for a benevolent dragon's posture, try using a dog or cat. Assuming that your dragon is a four-legged creature, you can follow the basic proportions of dogs and cats, using their familiar poses as models for the body language of friendly dragons.

Dwellers of the Red Forest
It's an extremely rare occurrence, but every now and then an intelligent, good-natured dragon will befriend, and even act as protector to, a human companion. (Art by Kerem Beyit.)

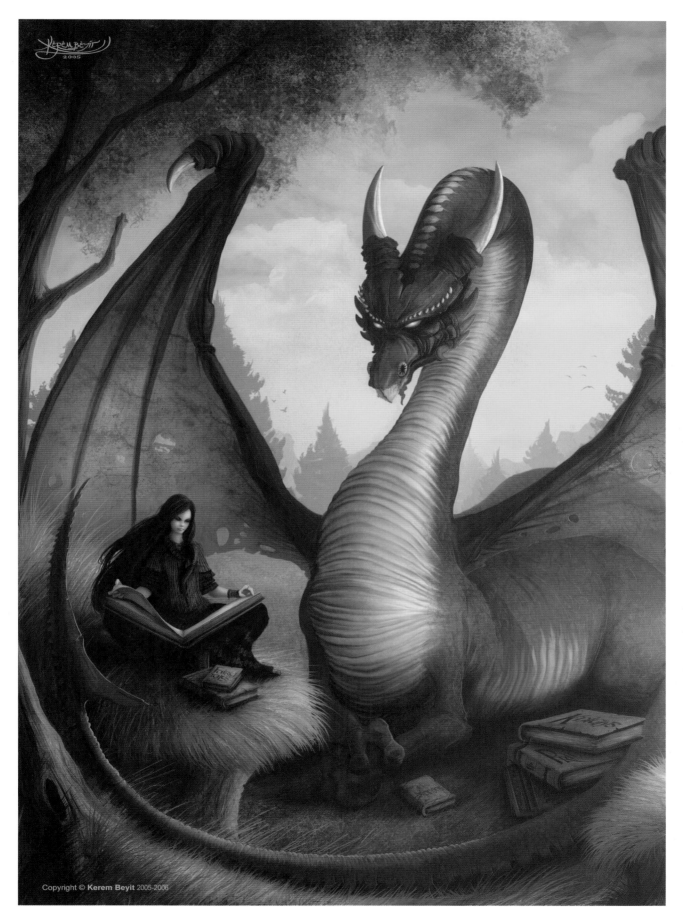

Classic Dragon

Here, we present a classic depiction of a dragon, with a lizard-like or crocodilian body; a dinosaur-like head; a pair of giant, bat-like wings; and, of course, the massive tail. Although this creature appears impressive, its construction, as you can see by reviewing the steps shown, is relatively straightforward.

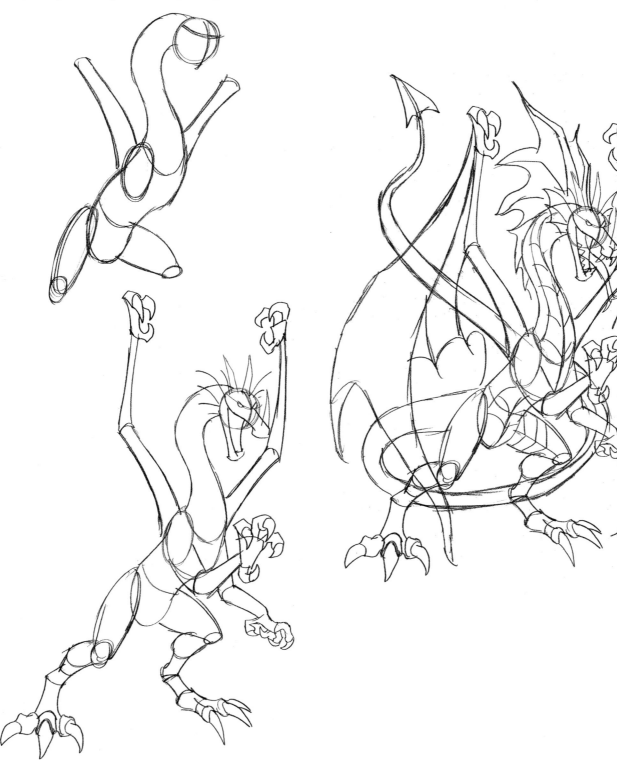

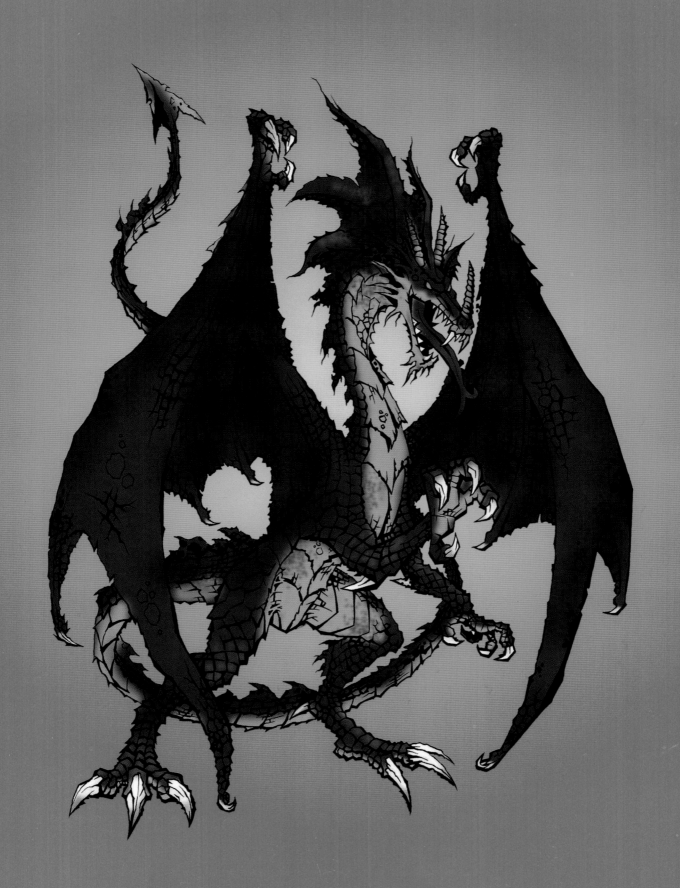

Wyrm

This blue-skinned dragon displays a magnificent, almost regal personality. (Art by Mauro Herrera.)

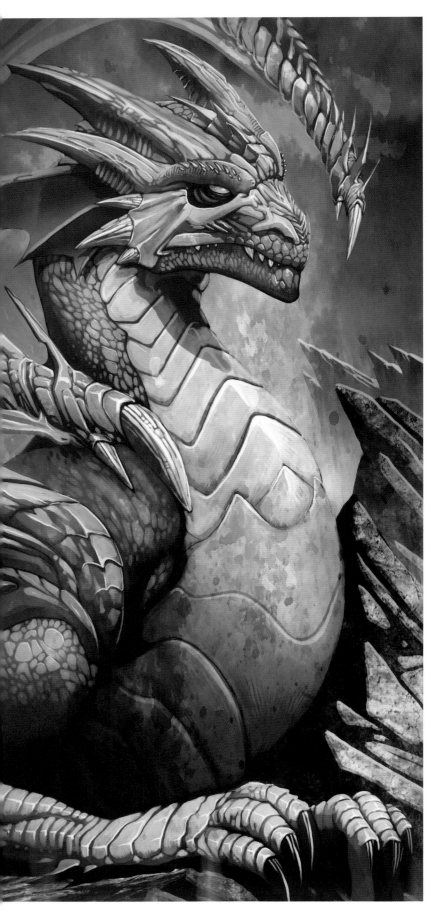

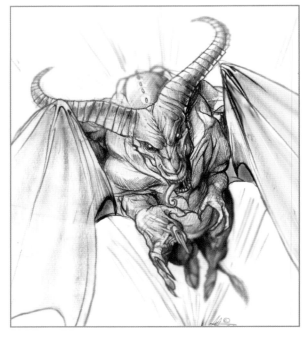

Leaping Buck

Notice how the artist has carefully foreshortened the body and limbs in this drawing to give the impression that this young male dragon is catapulting toward us. (Art by Amelia Mammoliti.)

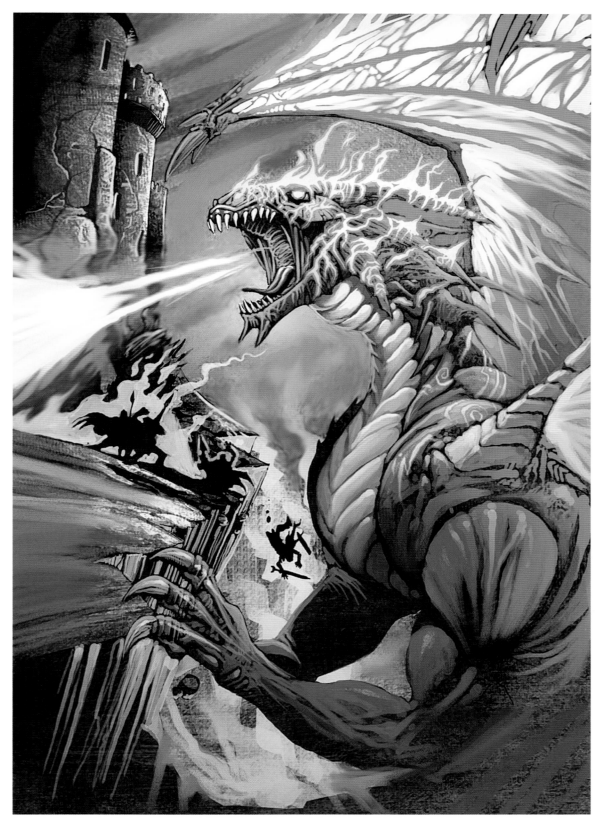

Abysmal Wyrm
A truly hellish dragon attacks a castle,
and the defenders have no chance.
(Art by Mauro Herrera.)

SEA DRAGON

Sailors and pirates have provided many accounts of aquatic dragons who live in the ocean. These creatures usually keep to themselves, but on rare occasions they have been known to attack ships and devour entire crews. Despite its unusual shape, this is actually an easier character to draw than our standard dragon. Its body is one long, snaky cylinder, which tapers down to a very narrow tail.

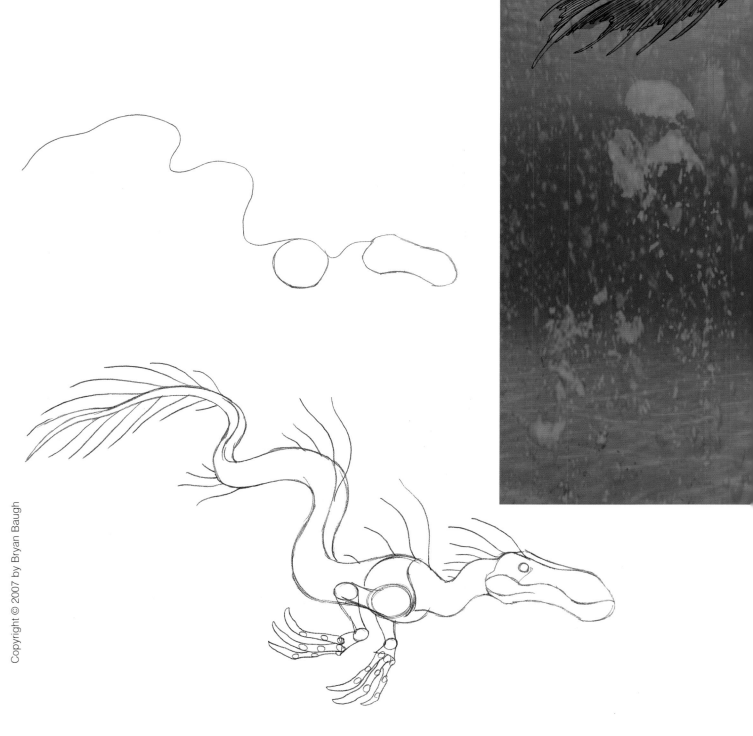

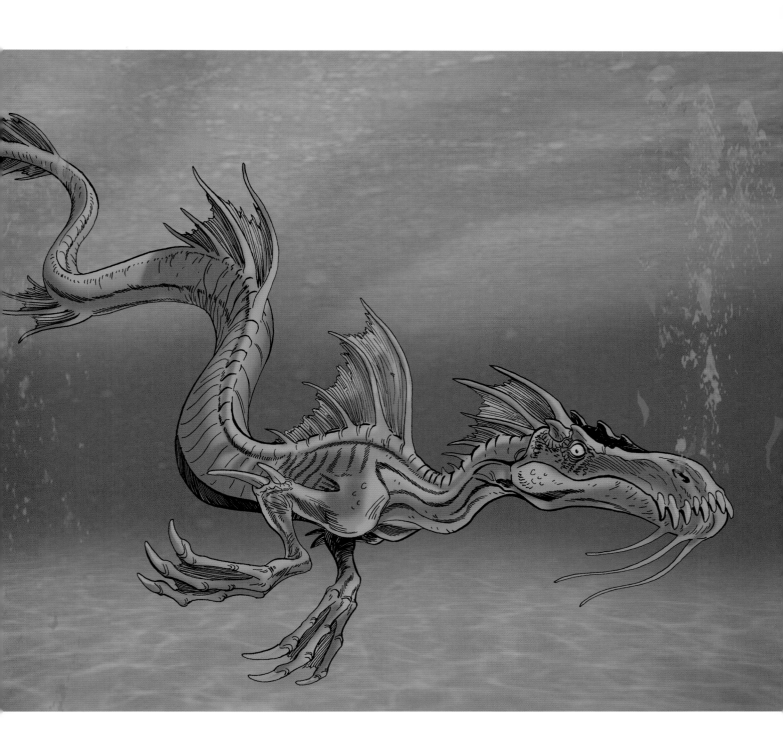

FIRE SERPENT

A very rare and unusual species of dragon, fire serpents hail from Eastern regions and resemble giant, fire-breathing snakes. They move about by slithering on the ground or flying through the air. Despite its strange appearance, this character is also fairly simple to draw. The best way to start your fire serpent is to lay out the long, curving line of its spine. Then work out the odd shape of the head, constructing the crests, fins, and fangs as your final details.

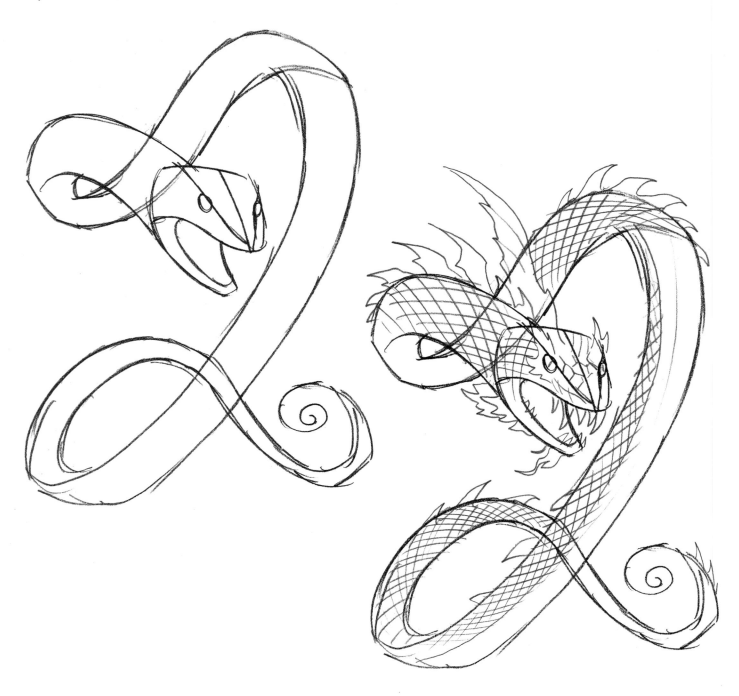

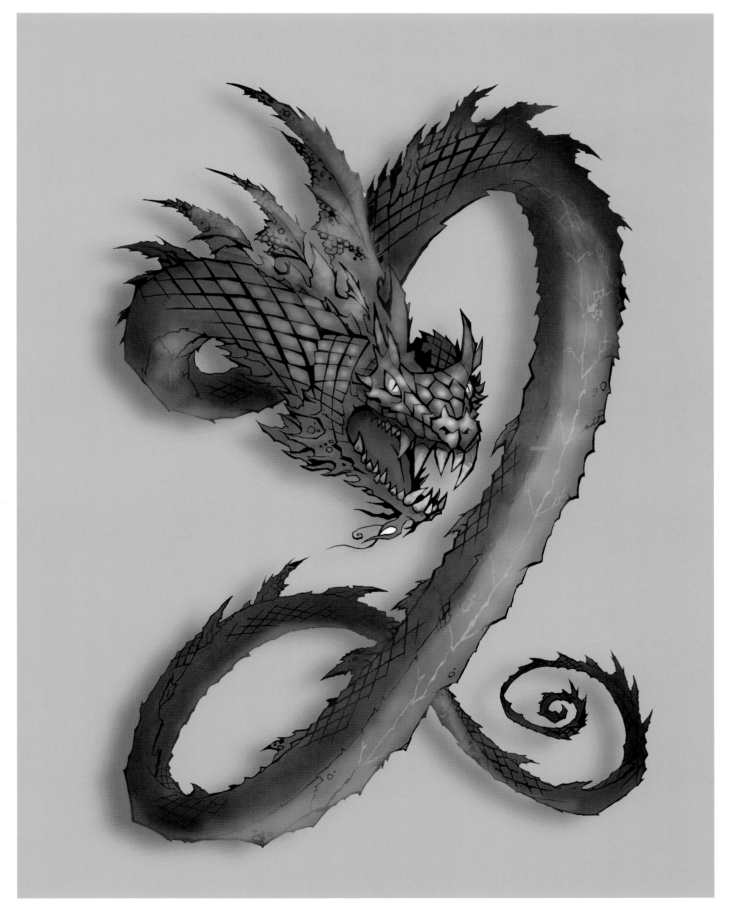

HYDRA

The mythological hydra is a five-headed dragon subspecies. Extremely aggressive and nasty tempered, hydras cannot breathe fire but are reputed to have a deadly, venomous bite. According to legend, if any of the hydra's heads is cut off, two more heads will grow back in its place

Drawing a hydra presents a challenge that seems mind-boggling, at least on first glance. How in the world do you go about drawing all these crazy serpentine shapes waving around and overlapping each other? Well, the secret to mastering this character is to draw each element one by one. Begin by laying out the heads' and necks' basic shapes, then add the details of eyes, teeth, and scales. (You'll confront a similar challenge, requiring the same approach, in the next part of the book, with the character called Medusa.)

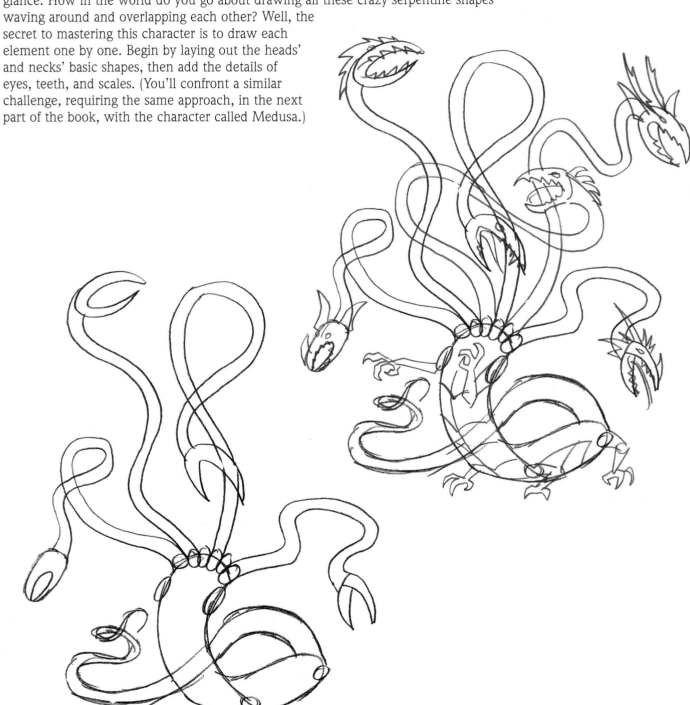

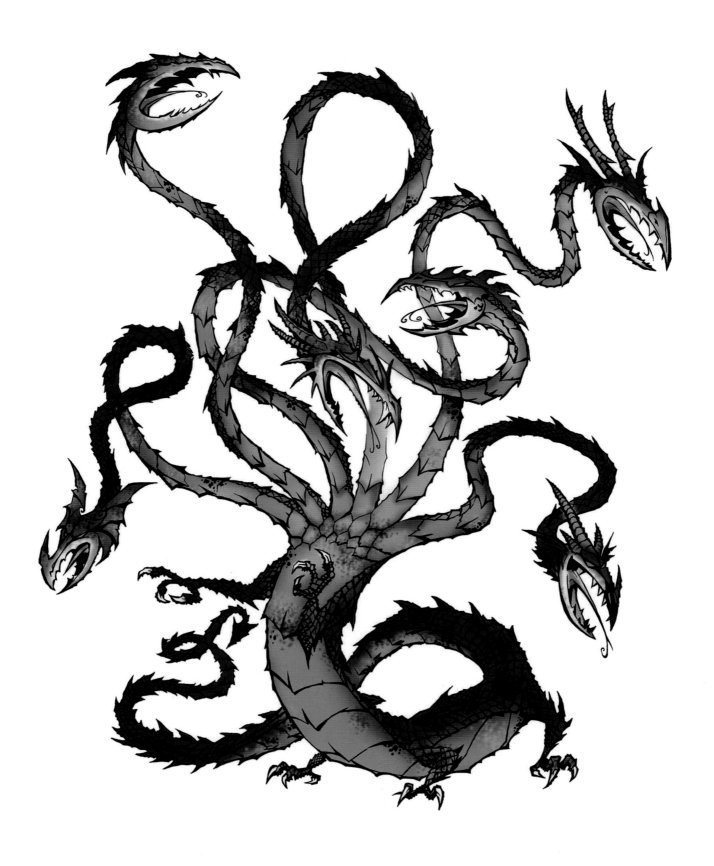

PART THREE
DENIZENS OF THE UNDERWORLD

BEYOND THE WORLD OF THE LIVING LIES THE SHADOWY UNDERWORLD— abode of the dead, the undead, and the demonic. Also known by the names Hades and Pluton, the underworld is the final dwelling place of men's souls. Eventually, all mortals—both good and evil—end up in some part of this vast, otherworldly kingdom. It is here that they will spend eternity.

Upon a man's death, his immortal soul will awaken to find itself standing on the jagged, rocky banks of the river Styx, also known as the River of Death. In some legends, the river emerges from the mouth of a cold, dark cave, its glittering black waters reaching back into the cave's impenetrable shadows. But according to other myths, Styx is a boiling red river of blood in the midst of an arid, fog-enshrouded wasteland. The soul must wait here, at the river's edge. Eventually, a small boat will emerge from the shadows and mist, helmed by Charon, the ferryman of the underworld.

As his small ferryboat bumps gently against the river bank, Charon demands one obolus (a Greek silver coin) in exchange for a ride across the Styx. (This is the reason for the ancient tradition of burying corpses with coins placed over their eyes or under their tongues—to ensure that they will have the fare to make their way to the land of the dead.) Once paid, Charon beckons his new passenger into the small boat, starts rowing with his oar, and begins the slow, eerie journey across the River Styx.

Just where the soul of the deceased mortal will go after reaching the shores of Hades and disembarking from Charon's boat depends on what kind of person he or she was in life. The underworld has three levels:

The souls of good, noble, heroic men and women go directly to the beautiful, lushly green Elysian Fields, where they will enjoy an infinity of happiness, free of pain, sorrow, and disease.

Less virtuous individuals will find themselves in Asphodel, a dull and dreary land of withered foliage and cloudy gray skies.

And finally, the souls of offensive, indisputably evil people are condemned to Tartarus, where they will suffer an eternity of punishment and torment. This was the largest— and, naturally, most feared—of the three levels.

Belly of the Beast
A monstrous, four-eyed, goat-faced arch demon perches above the fires of Hades in this nightmarish rendering of the under-world. (Art by Allison Theus.)

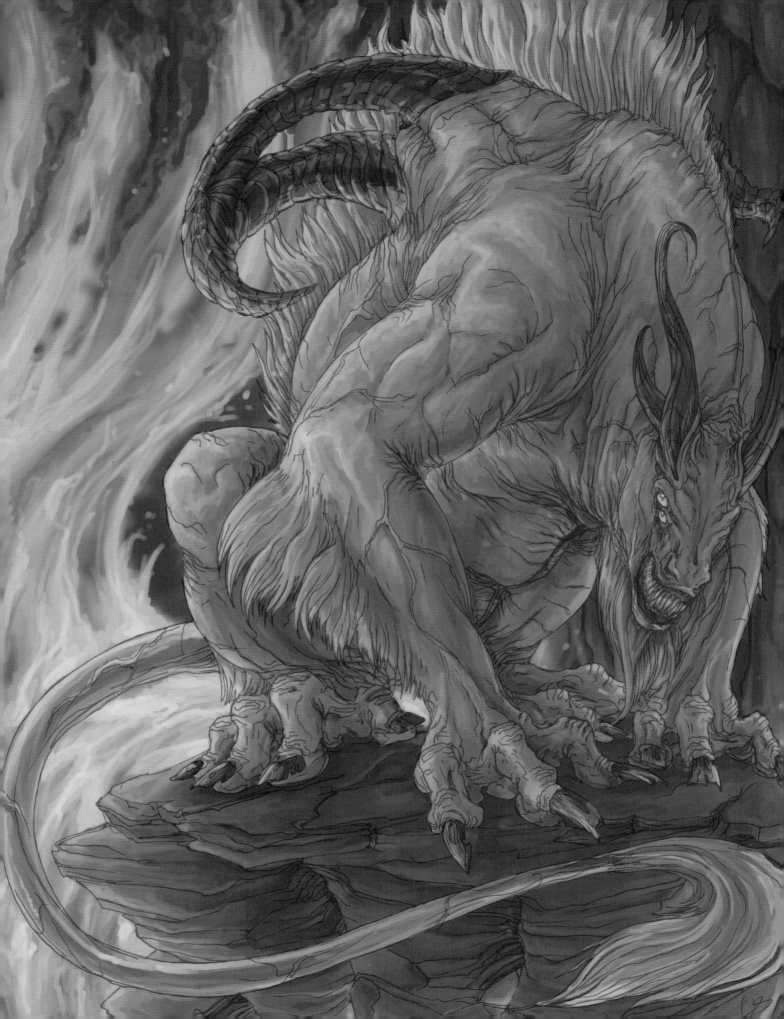

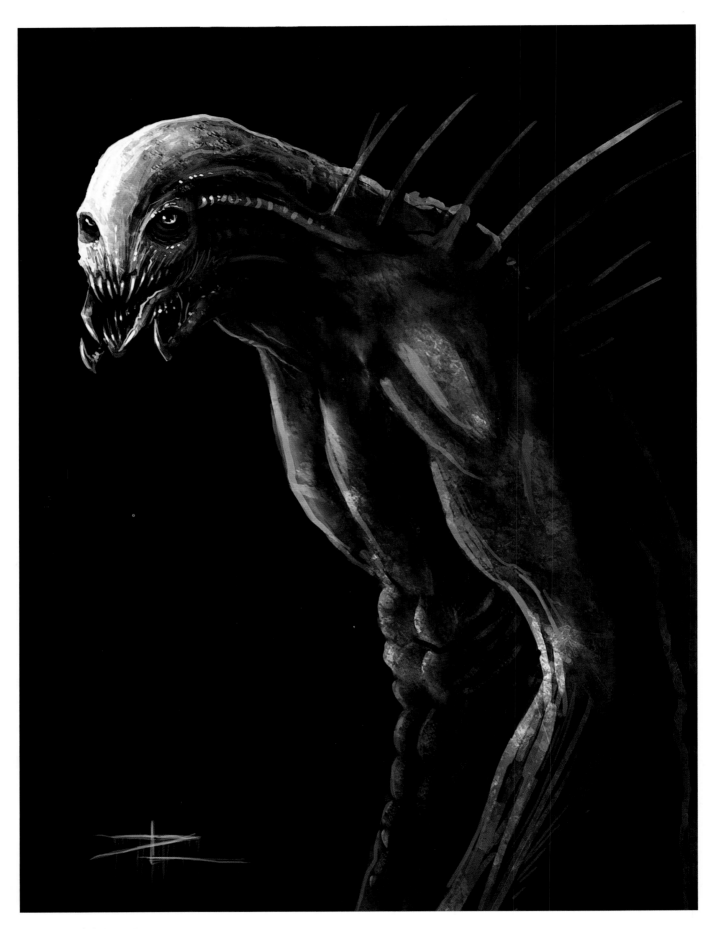

On rare occasions, living mortals dangerously venture into the underworld for some arcane purpose. Usually, such journeys are made to acquire some dark magical power or supernatural trophy. Like the dead, these foolhardy mortals must pay Charon to transport them across the river Styx to Hades. But although they may make this passage, the still-living may not enter the Elysian Fields or Asphodel. Living mortals who journey to the underworld may traverse only the cursed region of Tartarus. This is incredibly risky, because Tartarus is populated by a variety of evil entities who dislike the intrusion of the living into the land of the dead. Monsters, gorgons, and terrible "undead" beings abound, eager to destroy any living person they discover—and to keep them in Hades forever. Thus, few living mortals who visit the underworld ever make it back to the world of the living.

In this part of the book, we will meet—and learn to draw—some of the underworld's dark denizens.

▶ The Undead Legionnaire

An undead knight pauses to contemplate the doom of his unfortunate victims in this spectral portrait. (Art by Amelia Mammoliti.)

◀ Not Human

A gargoyle-like creature lurks threateningly in the shadows in this shiver-inducing depiction. (Art by Daniel Lundquist.)

CHARON

This ghost has the eternal duty of ferrying souls from the world of the living, across the river Styx, to the land of the dead. On very rare occasions, living people may have some terrible need to travel to the land of the dead, and Charon will transport them, too, although he must be well paid in gold if such travelers expect him to take them back to the world of the living once their grim mission is complete. A frightening figure of death, Charon's appearance is simply that of a skeleton wrapped in ragged cloaks. This character may appear terribly difficult to draw, because you have the added challenge of his boat. But, just as with an animate character, the boat can be broken down into a series of simple shapes that any artist can imitate. Once you nail those basic shapes, it simply becomes a matter of adding all the details.

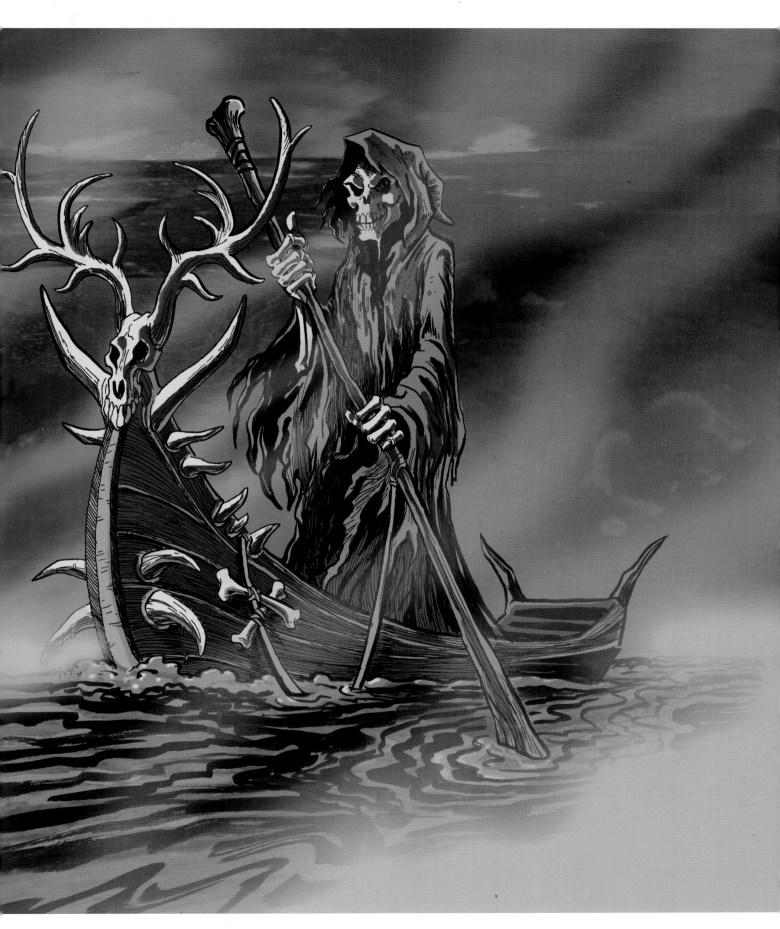

SUCCUBUS

Every bit as evil as she is deadly, the succubus is a female demon who uses her attractive physical appearance to seduce men whom she wishes to destroy. If you got a handle on drawing female characters back in the first part of this book, then the succubus shouldn't present a problem. Basically, she is just a female figure with horns, clawed fingers, and a pair of giant bat wings attached. The wings will be the most difficult part. Start the wings by laying out the framework of jointed bones in the pose you want. Then draw the webbing.

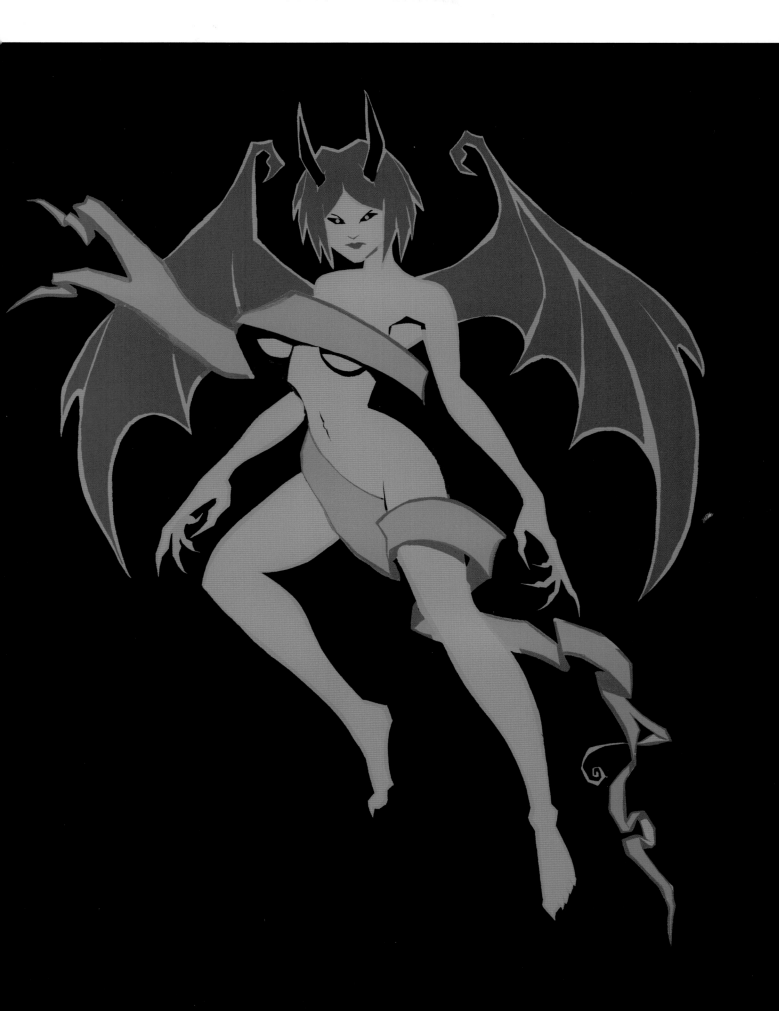

GARGOYLE

Although they are extremely evil and look terribly demonic, gargoyles are not technically demons. Rather, they can be described as a species of winged, reptilian humanoids, of subhuman intelligence. Because of the large population of gargoyles that thrives in the underworld, however, they are frequently associated with demons. Gargoyles serve as airborne guardians of the underworld's many temples. Like orcs, gargoyles desire the exterminations of mankind, although their efforts toward this goal are more random and less organized than those of the orcs. On occasion, gargoyles have been known to fly out of the underworld and take roost in the world of the living, where they boldly prey on human cities, causing much havoc and mayhem. From a human perspective, they are thoroughly monstrous, destructive creatures.

This character will present you with a few interesting challenges. The first and most obvious is its pose. To draw this roosting gargoyle, you must give it a crouching pose. To get this pose right, you've got to fall back on your basic human-figure drawing skills and think of the gargoyle's body as similar to that of a very thin, wiry human being—which it basically is, except for the very inhuman shapes of the head, hands, feet, and wings. Just draw the body one piece at a time: nail down the torso, then the legs, then the arms. The gargoyle's scaly hide presents another challenge. It looks complex—and maybe a little confusing at first—but if you examine the step-by-step process, you'll see that the texture of the scales is just a series of cross-hatching lines.

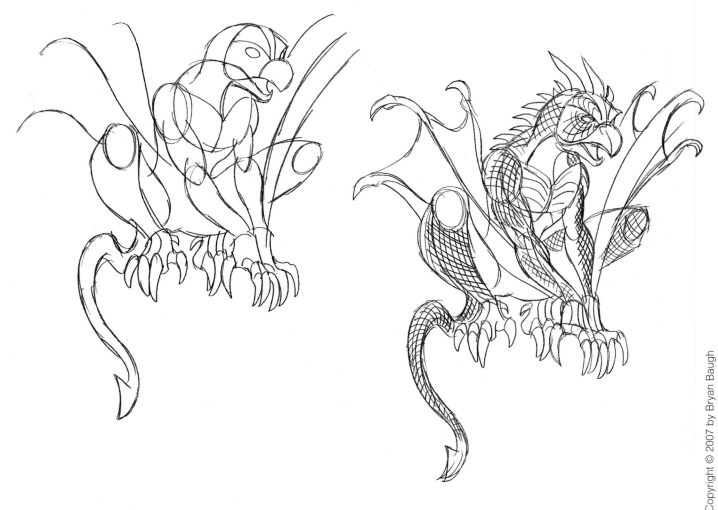

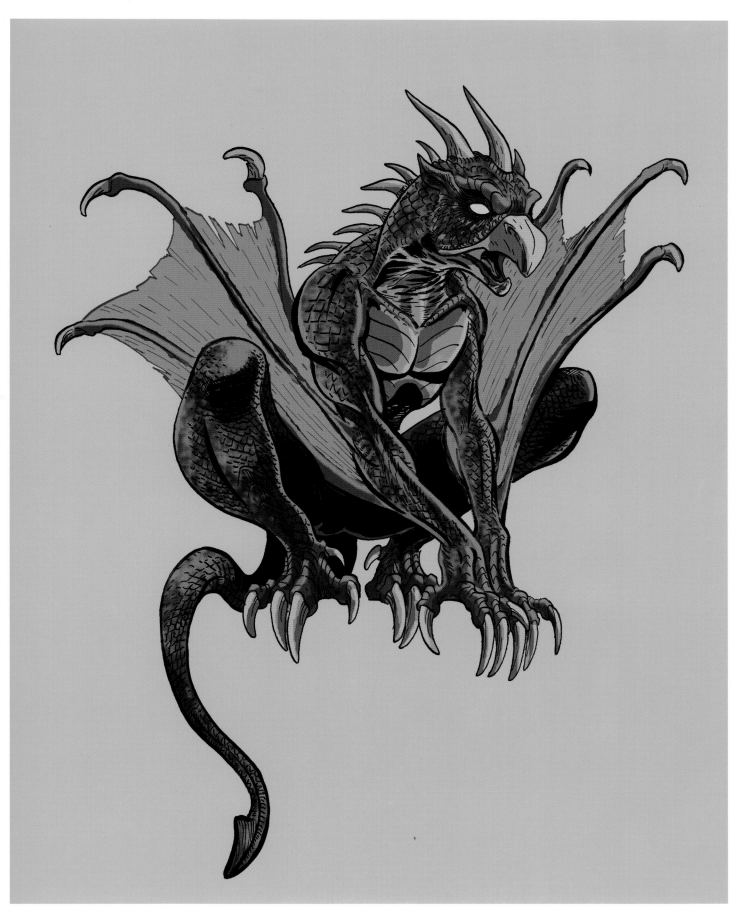

Undead Knight

Sometimes, the souls of no-longer-living people just cannot rest, cannot really die. When this happens, the "undead" rise up from their graves and wander the earth. There are several reasons why this may occur. Being undead may be an eternal punishment for some crime committed in life —even though the person's body has died, his or her spirit has not been permitted to enter the underworld. Or it may be that a witch or evil sorcerer has summoned the deceased individual. Or it may be that the deceased individual returns purposefully, by a conscious act of will, to complete some mission left unresolved in life. *Or* it might be that the deceased individual just simply fails to understand that he or she is dead.

Whatever the reason, these undead spirits are terrifying things to encounter. They may appear as ghostly phantoms of their living selves or as skeletal, rotted corpses. Drawing an undead knight is not unlike drawing a very thin person and then clothing the figure in an appropriate costume. But you will want to make his face skull-like, and to add signs of age and wear-and-tear to his costume.

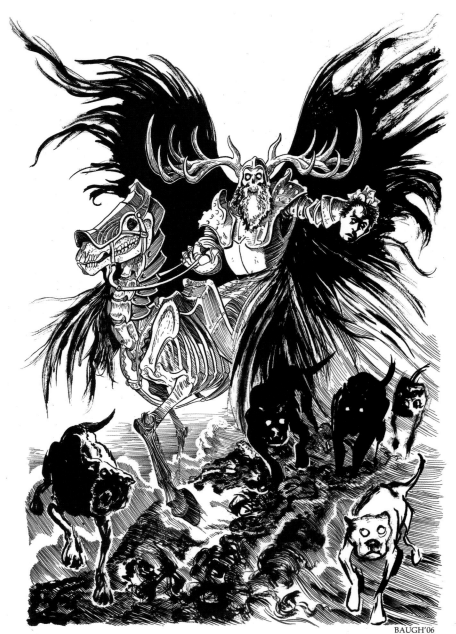

The Huntsman
An undead knight on a skeleton horse hunts living victims with the help of his ghostly hounds. (Art by Bryan Baugh.)

BAUGH'06

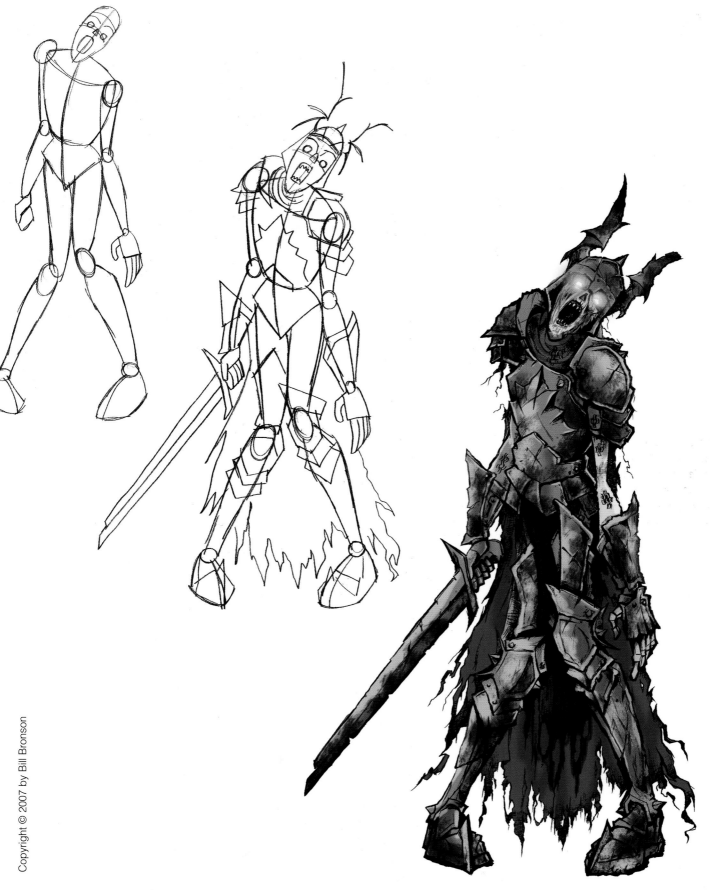

CERBERUS

This giant three-headed dog is the guardian of the underworld. He protects its temples and entryways and will viciously attack and kill those living humans who trespass into this forbidden realm.

I won't lie to you: drawing Cerberus is a daunting challenge. Placing three thick, muscular necks on one set of doggy shoulders—and making the form look natural, not crowded and awkward—is not an easy task. But like every other challenge in this book, it can all be worked out if you are willing to study the character closely and examine how it breaks down into simple shapes. These simple shapes are very easy to draw in and of themselves—it's just the arranging of the shapes that can be tricky. On this one, you'll need to follow the steps especially carefully.

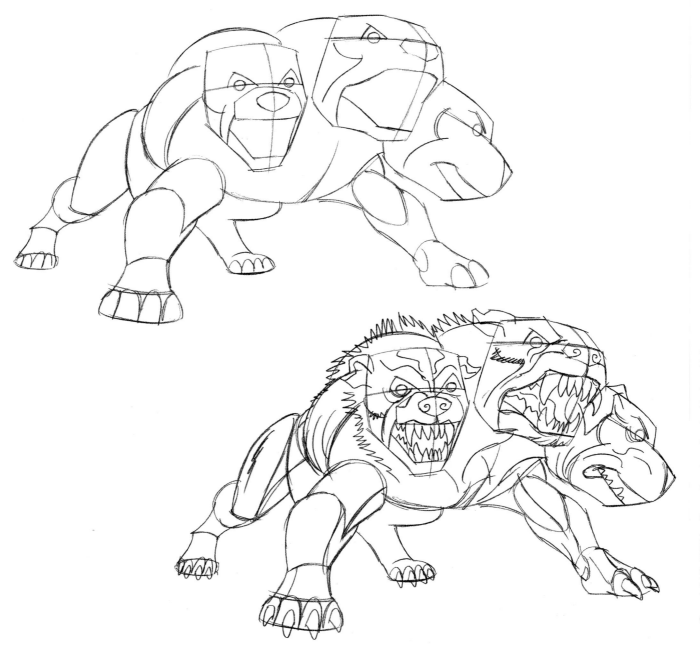

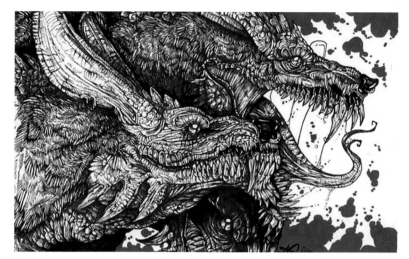

Cerberus, the Hell Dog
This handsome portrait gives a profile view of the three-headed demon dog who guards the land of the dead. (Art by Amelia Mammoliti.)

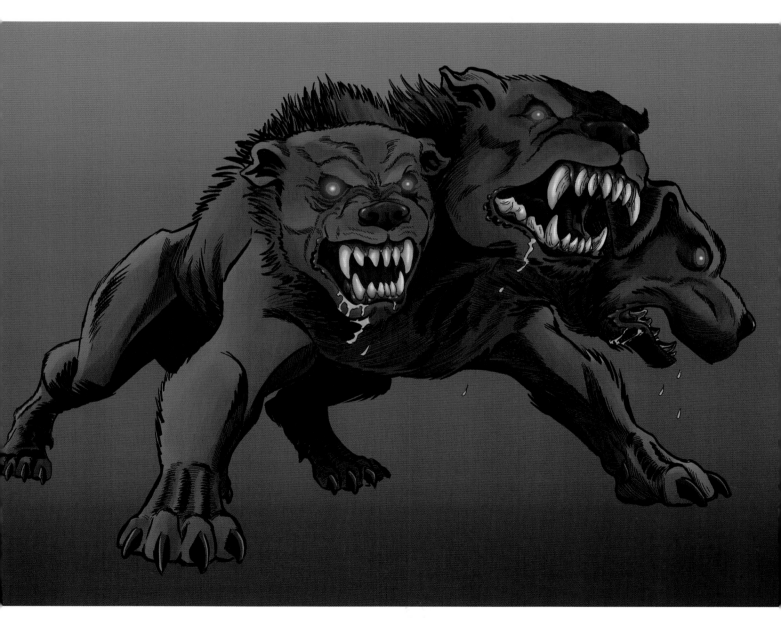

MEDUSA

Once a good person and a lovely woman, Medusa fell in love with Poseidon, the Greek god of the sea. When the goddess Hera found out about this affair, she became so jealous that she put a dreadful curse on poor, beautiful Medusa. The girl's skin took on a hideous, scaly texture, her teeth grew into fangs, and her hands became claws. And, most striking of all, Medusa's lovely blonde hair changed into a squirming nest of snakes, each serpent growing right out of her scalp. Medusa had been transformed into a gorgon—a creature so ugly that anyone who looked into her eyes would be turned to stone. As if that wasn't enough, Hera cast Medusa into Hades for the rest of eternity. Her heart and mind shattered with horror and rage, Medusa became one of the underworld's most evil inhabitants. A true monster, she seeks to kill all those who encounter her.

Drawing Medusa will be an obvious challenge because of all those snakes coming out of her head. The secret is to draw her head first. Then start adding the snakes, one at a time. The individual snakes aren't so tricky if you just look at them as curving cylinders. Part of the fun of drawing them lies in showing how they coil, overlap, and entangle—giving them a very squirmy appearance.

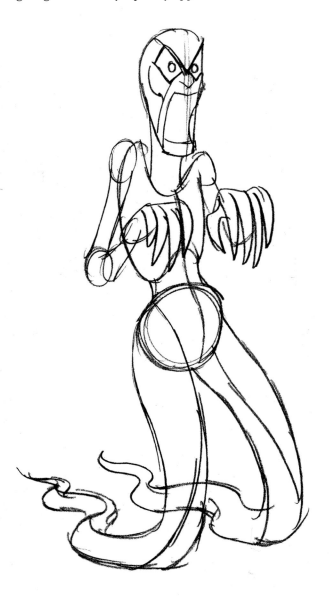
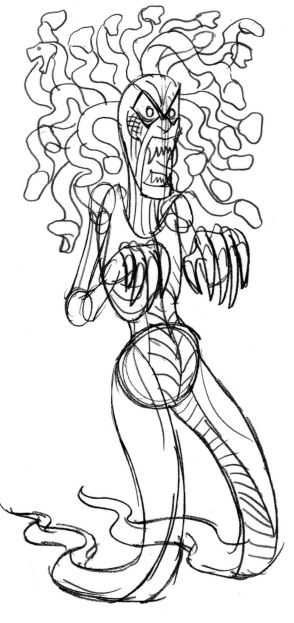

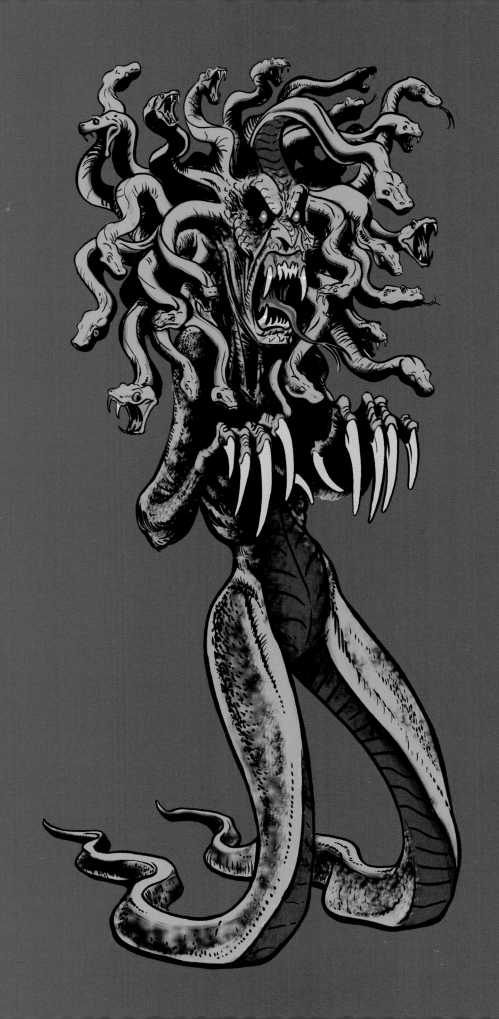

Arch Demon

Arch demons rule the darkest regions of the underworld, overseeing the torments of the cursed souls and the destruction of those living trespassers who dare journey into the land of the dead. Arch demons are, however, unable to influence events in the peaceful Elysian Fields, nor do they have any power over the blessed souls who end up there. Like the succubus, this character should not present a huge challenge if you have gotten a handle on basic human figures. This arch demon, as inhuman as he is, is built of a very human-like head, torso, and arms, with short but muscular legs. What make him such a monster are his massive horns, his three-fingered, clawed hands, and those giant wings.

Malakyne and Shinande
In this riveting black-and-white drawing, the arch demon Malakyne has captured Shinande, the queen of the sylphs—a rare breed of beautiful, winged fairyfolk. (Art by Jeff Fairbourn.)

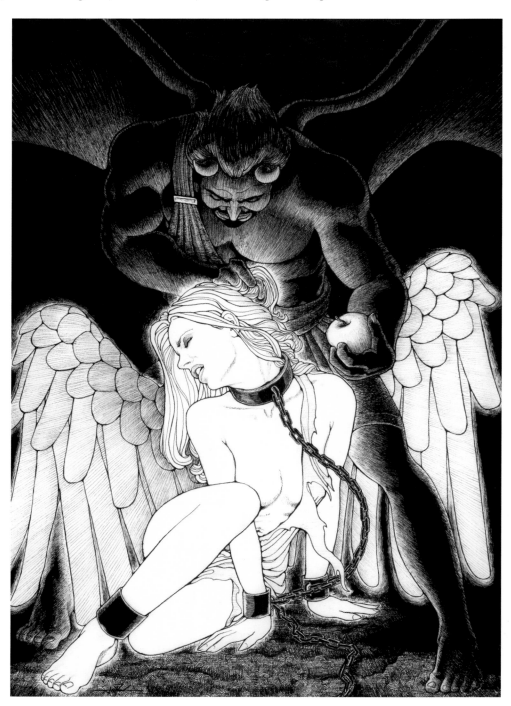

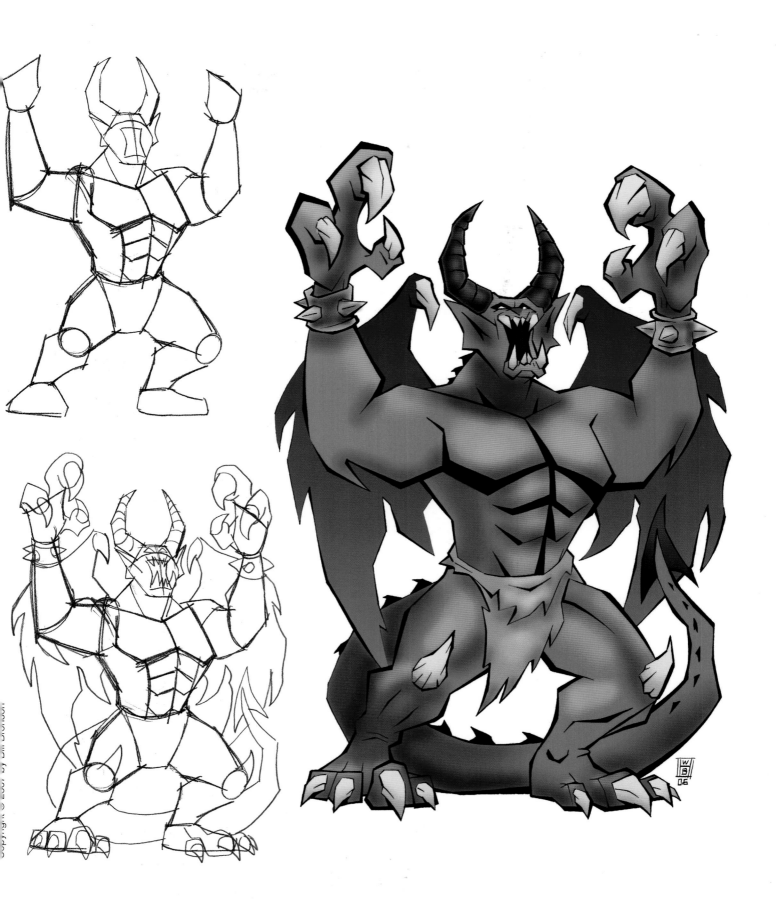

INDEX

arch demon, 127, 142–43
archers, 26, 36
armor: drawing, 30, 32
Asphodel, 126, 129

barbarian, 9, 14–15, 16–17, 22–25, 47, 84. *See also* Conan the Barbarian
Batman, 41
Baugh, Bryan [art], 14–15, 16–17, 22–23, 24–25, 26, 27, 29, 30, 36, 46, 48–49, 55, 58–59, 60, 62, 63, 64, 68, 72, 73, 75, 76, 78–79, 80–81, 83, 84, 87, 91, 95, 97, 120–21, 130–31, 136, 138–39, 140–41
berserker, 56, 61
Beyit, Kerem [art], 67, 70–71, 77, 102, 109, 112, 115,
birds. *See* griffin, roc
boar giant, 91
Bronson, Bill [art], 11, 30, 31, 33, 34, 35, 37, 38–39, 45, 51, 52, 53, 54, 55, 61, 72–73, 74, 82, 83, 92–93, 94, 96, 100–101, 103, 104–5, 106–7, 116–17, 122–23, 124–25, 132–33, 137, 143

cannibal, 62
castle, 34
centaur, 90, 92–93
Cerberus, 138–39
Charon, 126, 129, 130–31
Chinese dragons, 114. *See also* fire serpent
Conan the Barbarian, 9, 10–13, 41
cyclops, 86–87

demons. *See* arch demon, gargoyles
dogs. *See* Cerberus
dragons, 2–3, 9, 11, 13, 32, 88–89, 99, 108–125
dwarf, 38–39

elf, 36, 37; female, 45, 55
Elfquest, 13
Elric of Melnibone, 13
El Trauco, 65
Elysian Fields, 126, 129, 142

Fairbourn, Jeff [art], 13, 21, 28, 40–41, 44, 49, 56, 69, 84, 85, 90, 114, 142
fairy, 44
fairy tales, 56, 88

fantasy adventure genre, 9, 56, 88
fantasy characters: drawing, 20
female adventurer, 48–49
female characters: drawing, 41, 45, 132
fire serpent, 122–23
Frazetta, Frank, 12
frost giant, 83, 84

gargoyle, 128, 134–35
giant, 82–85. *See also* boar giant, cyclops
goblin, 68–71, 90
gorgon, 140
great king, 32–33
griffin, 102–3

Hades, 126, 127, 140
Hall, Bejamin [art], 12, 47, 50, 76
Hall, Marlena [art], 29, 55, 139
Hall, Zach [art], 22, 36, 80, 91, 97
Hera, 140
heroic male characters: drawing, 18
Herrera, Mauro [art], 9, 18, 19, 26, 42, 43, 56, 65, 118, 119
horse anatomy, 92, 101
Howard, Robert E., 9, 13
hydra, 124–25

kings. *See* great king
knight, 10, 21, 30–31, 32, 98. *See also* undead knight, warrior
Kraken, 106–7
Krisinski, Grzegorz [art], 39

lava giant, 83, 85
lizard soldier, 95
Lord of the Rings, 9–10, 12, 13
Lundquist, Daniel [art], 88, 99, 128

male characters: drawing, 18
Mammoliti, Amelia [art], 108, 110, 111, 114, 118, 129, 139
Medusa, 140–41
mermaid, 94
minotaur, 90, 96–97
Moorcock, Michael, 13

Naglfar (mythological Norse ship), 57
nymph, 40

Odin, 50
ogre, 80–81
orc, 16–17, 72–75

Pini, Richard, 13
Pini, Wendy, 13
Pluton, 126
Poseidon, 140
princess, 46–47

ranger, 26–27
Red Sonja, 13
roc, 104–5
Russell, P. Craig, 13

sea dragon, 120–21
sorcerer, 58–59. *See also* wizard
sorceress, 52–53
storm giant, 83, 85
Styx, 126, 129, 130
succubus, 132–33
swashbuckler, 28–29
sylph, 142

Tartarus, 126, 129
Theseus, 90
Theus, Allison [art], 2–3, 113, 127
thief (female), 54
thug, 64–65
Tolkien, J. R. R., 9
troll, 1, 6–7, 30, 66, 67, 76–79

undead knight (legionnaire), 129, 136–37
underworld, 126–43
unicorn, 100–101

Valkyrie, 50–51
Vehige, Adam [art], 1, 6–7, 32, 66, 79, 86, 98

warlord, 60
warrior, 9, 18, 19, 20; female, 42, 43. *See also* barbarian, berserker, knight
White, Dave [art], 10, 12, 20, 50, 91, 93, 105
wings: drawing, 132
witch, 63
wizard, 13, 34–35; female, 14–15. *See also* sorcerer, sorceress
Wolverine, 41
Wonder Woman, 41

X-Men, 41